IN THE FOOTSTEPS OF THE ARTIST

Thoreau and the World of ANDREW WYETH

PHOTOGRAPHERS
James A. Warner and Margaret J. White

The Middle Atlantic Press
Wilmington, Delaware

IN THE FOOTSTEPS OF THE ARTIST
Thoreau and the World of ANDREW WYETH

A MIDDLE ATLANTIC PRESS BOOK

First Middle Atlantic Press printing, October 1986

Printed in Spain by Printer I.G.S.A.

Library of Congress Cataloging-in-Publication Data

Warner, James A.
 In the footsteps of the artist.

 1. Wyeth, Andrew, 1917- – Sources. 2. Chadds Ford
(Pa.) in art. 3. Thoreau, Henry David, 1817-1862 – Influence.
4. Nature (Aesthetics) I. White, Margaret J. II. Title.
ND237.W93W37 1986 759.13 86-12873
ISBN 0-912608-33-1

In The Footsteps Of The Artist

Foreword

Each of us lives in two different worlds: an exterior world which is physical and visible, and an interior world which is intangible, invisible. We become aware of the existence of such a duality through the processes of growing maturity and an expanding sense of self-perception. How we view ourselves in relation to life around us, where we place ourselves within those relationships, why we live, and what we live for are age-old questions that every self-searching pilgrim asks of himself at some point during his life.

These two worlds exist simultaneously. With or without our knowledge of their existence, we move between them and within them. They are inseparable in their complexities. The exterior world in which we live is the one into which we are born, in which we move about and spend our days. It is the one to which we respond and react and in which we carry out our work and our pleasures within the space of our allotted time.

The interior world is a more complex realm. It is intimate, intensely personal, subjective, not always accessible; it is sometimes, but more often not, clearly defined. It is the world of our thoughts and our daydreams; of conversations with ourselves at deeper levels than it is sometimes possible for us to understand. It is the world of the synthesis, the crystallization and rationalization of our actions and reactions to the exterior. We enter it in the most subtle ways, under unpredictable circumstances, at the highest or in the lowest moments of our experiences. Consciously or unconsciously, we are able to withdraw into it, entering and exiting its invisible boundaries.

Children live in it by following the path of least resistance: through imagination and fantasy. Some adults never leave it; some never learn how to use it or benefit from its intrinsic value. Like its counterpart in the exterior, it is not still; but it is a silent world. It has a voice audible only to the pilgrim who will listen long enough to hear it. And when it is heard by the one who has listened, it will search for an outlet in which to display its influence.

For Henry David Thoreau it commenced with an experiment, a retreat to Walden Pond where he dwelt in the exterior world of a wood while living the interior world of his dream. By listening to the interior voice within, he was able to work out a meaning for his existence and give expression to the same through matchless essays for all time.

For Andrew Wyeth it finds its outlet in an artistic expression unparalleled in the history of American art. His powerful visions are his intensely personal reactions to the two exterior worlds between which he divides his life: a summer world in Maine and a winter world in Chadds Ford, Pennsylvania.

In light of these observations, there is a reason for our chosen subject of this portrait essay. Jim Warner's love for the art of Andrew Wyeth, his intermittent visits to Chadds Ford over a period of fifteen years to photograph the village and the countryside that are a source of inspiration for the artist's work in Pennsylvania, and his sharing of that love and a great number of those visits with me, has brought his dream of such a project to fruition. It is by no mere happenstance or contrivance that the words of Henry David Thoreau have been chosen to carry the theme. In the research involved for this project, and through conversations with friends of the artist, it seemed no coincidence that there is a unique parallel between the subtle magnetism of the artist's images and the introspective observations of the Delphic

Yankee. Anyone who spoke to us about the artist was quick to remind us that Andrew Wyeth, the son of the great American illustrator and painter N. C. Wyeth–who shared a deep spiritual affinity for the pilgrim of Walden Pond–was born on the 100th anniversary of Thoreau's birth.

To state that such a fact alone supports the reason for our chosen theme is insufficient. One must read the words while viewing the portraits of the artist's world in Chadds Ford to discover the parallel for himself. For the truth lies beneath the surface. It is not in the exterior world where the parallel exists, but beneath the surface in the interior, where we discover the essence to support the truth.

Andrew Wyeth is an artist whose travels take him not far, but deep into the environment he has always called home. Born in his parents' home in Chadds Ford, Pennsylvania, on July 12, 1917, Andrew Wyeth was the fifth and last child born to Newell Convers Wyeth and Carolyn Bockius Wyeth. His father had come to Chadds Ford in 1903 as a student in the summer art school of the renowned American illustrator, Howard Pyle. It was the rolling hills and open meadows of this fertile river valley that would make their claim upon the New England-born N. C. Wyeth. He married and settled in the Ford and raised his family there. By 1917, his own success in the world of illustration had afforded him the opportunity to build and maintain a home and a studio. The family life and the working life of this greatly sought-after master of such illustrated classics as *Treasure Island, Robinson Crusoe, Kidnapped, Robin Hood,* and *The Last of the Mohicans* blended to create an almost self-contained environment for the earliest learning experiences of the Wyeth children. They grew up in their father's studio surrounded by great art and visiting artists, classical music, selected books of lit-

erature and poetry, all fed by a father's insatiable quest for the highest and deepest level of awareness and appreciation for nature, and the enjoyment of every given moment in her presence–to which was added the security of a mother's quiet, strong, and gentle presence within the family home. Three children would become recognized artists in their own rights. Two would marry artists; one would become a musician and another a scientist. It was a family raised in the pursuit of each one's individual uniqueness. Each would follow his own course; each responded differently to the creative environment in which all had been raised.

The rolling hills and meadows and the woodlands of the rural, open countryside of the Brandywine River valley served as backdrop for the life of N. C. Wyeth's family. Except for family summers spent in residence along the coast of Maine, for Andrew Wyeth it would be the memories gathered from solitary walks in childhood, over these hills, through these woods and around this countryside that would nourish, sustain, and later feed the dreams that were the drapery of his vision.

It was the interior world of Andrew Wyeth, a world of vivid imagination fired by memories, that would drive him with the desire to extract the essence of every encounter with nature, with the people and places that made up his world. Drawing and painting would become the medium for his passionate response to his private realm.

An artistic career spanning more than fifty years of perfecting individual technique and absorbing the most minute and intimate details of his environment would prompt the art world to label him a consummate painter of the American scene. But the art of Andrew Wyeth cannot be re-

stricted to place or locality by the use of exterior labels. His world is not an exterior world of landscapes and portraits. His is an inner vision that strives through the perfection of artistic expression for what Thoreau would give meaning to in words:

"I wanted to live deep and suck out all the marrow of life, to live so sturdily and Spartan-like as to put to rout all that was not life; to cut a broad swath and shave close, to drive life into a corner, and reduce it to its lowest terms..."

Thoreau's observations came from an encounter with life and nature in a New England wood. But his thoughts transcend external boundaries. They are as universal in their spirit as are the images and compositions of Andrew Wyeth's art.

Herein are our own portraits of the area around Chadds Ford, Pennsylvania, that make up the exterior world of Andrew Wyeth. The area portrayed is only a few square miles, a small patch of countryside within a larger river valley.

We invite you to share this visit with us.

The river is the Brandywine.

The village, Chadds Ford, Pennsylvania.

The words are Henry David Thoreau's.

The world is Andrew Wyeth's.

M. J. W.
February, 1986

THE RIVER IS THE BRANDYWINE

THE VILLAGE, CHADDS FORD, PENNSYLVANIA

THE WORDS ARE HENRY DAVID THOREAU'S

THE WORLD IS ANDREW WYETH'S

The River

The river is by far the most attractive highway.

—Thoreau

For that portion of the Brandywine that flows through the village of Chadds Ford, Pennsylvania, and for the greater length of its course, the river is nature's own scenic highway through the heart of the Brandywine Valley.

From its origin in mountain brooks and streams in Pennsylvania's Welsh Mountains to its entry into the broad waters of the Delaware River, the Brandywine winds some sixty miles through valleys, meadowlands, and hills. These make up what has come to be known as "Brandywine country." Its amber waters flow through a diverse geographical area. A trip downriver by raft or canoe is a visit to this country's past. Today's traveler on the river highway has access to the same quiet reaches of ancient forests, deep meadows, and rugged canyons as its original inhabitants, an Algonquin-speaking nation of river Indians called the Lenni-Lenape.

The Brandywine from source to mouth was in Lenape territory. The river was their water supply, their means of transportation and their source of food. The Indians knew the Brandywine as a great spawning river for fish. Trout, sturgeon, and the shad for which the river was best known ran plentiful and fed the tribe.

To the Swedes and Finns of the mid-1600s, the earliest pioneers to establish settlements in the region, the Brandywine was known as Fishkill, for through its currents ran thousands of fish that packed the channels and moved in abundant supply. The Brandywine of early 17-century America was a primitive river where deer, bear, elk, and wolf roamed wild and free, and where the beaver (whose pelts became highly prized in Europe for making men's hats), like the Indian, made his home along the river banks.

By the late 1600s, Swedish, Dutch, English, and Welsh Quakers had firmly established themselves in the river valley. The expansion of settlements brought about the development of industry, and for the next two centuries the Brandywine and its contributary streams provided water power for hundreds of mills. Flour, lumber, and cloth mills were followed, in the 19th century, by tanning, iron, paper, and textile mills, and finally the gunpowder mill industry of the du Ponts. Many of these millsites are in ruin; others are preserved through the conscientious efforts of private organizations devoted to the region's heritage. Some, like Brinton's Mill, the artist's home on the Brandywine River, have been lovingly and carefully restored as private dwellings.

For its small size, the Brandywine shared a major role in the history of the developing nation. Early colonial industry was powered by its waters; military history was fought across its shores during the Battle of Brandywine in 1777. And in the 18th-century an artistic heritage to which the river valley gives its name began in an abandoned grist mill that served as the summer school studio of the renowned American illustrator, Howard Pyle.

The past and the present exist simultaneously in the valley of the Brandywine. Here man is striving, through local government and privately funded organizations, to preserve the beauty of the valley and the most precious of its natural resources, the gently flowing waters of the river.

The Brandywine. A timeless river in an ever-changing world...

THE RIVER SWELLETH MORE AND MORE,
LIKE SOME SWEET INFLUENCE STEALING O'ER
THE PASSIVE TOWN;...

HERE NATURE TAUGHT FROM YEAR TO YEAR,
WHEN ONLY RED MEN CAME TO HEAR–
METHINKS 'T WAS IN THIS SCHOOL OF ART
VENICE AND NAPLES LEARNED THEIR PART;
BUT STILL THEIR MISTRESS TO MY MIND,
HER YOUNG DISCIPLES LEAVES BEHIND.

WITHOUT OUTLET OR INLET TO THE EYE, IT HAS STILL
ITS HISTORY...IN SUMMER IT IS THE EARTH'S LIQUID
EYE, A MIRROR IN THE BREAST OF NATURE. SEE HOW THE
WOODS FORM AN AMPHITHEATER ABOUT IT, AND IT IS AN
ARENA FOR ALL THE GENIALNESS OF NATURE. ALL TREES
DIRECT THE TRAVELER TO ITS BRINK, ALL PATHS SEEK IT OUT.
BIRDS FLY TO IT, AND THE VERY GROUND INCLINES TOWARD
IT.

CONSIDER HER SILENT ECONOMY AND TIDINESS.

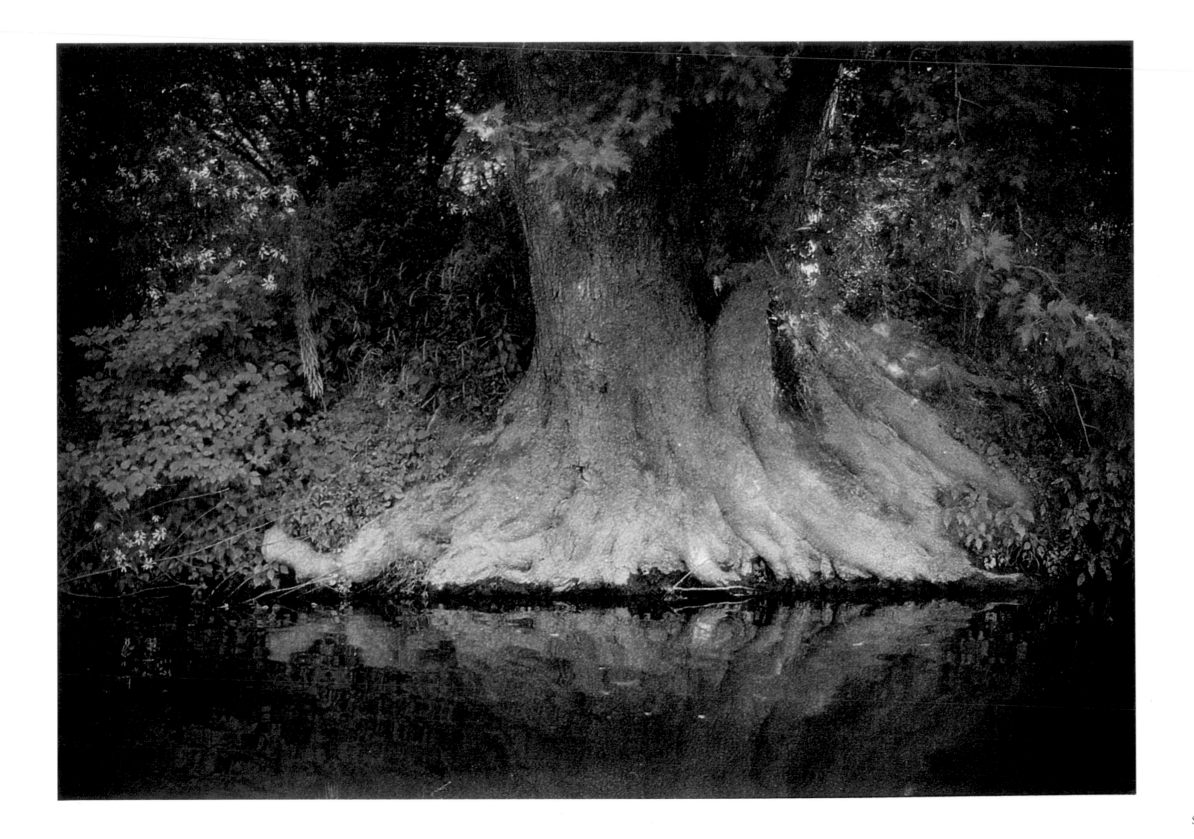

NATURE IS MYTHICAL AND MYSTICAL ALWAYS, AND WORKS
WITH THE LICENSE AND EXTRAVAGANCE OF GENIUS. SHE
HAS HER LUXURIOUS AND FLORID STYLE AS WELL AS ART.

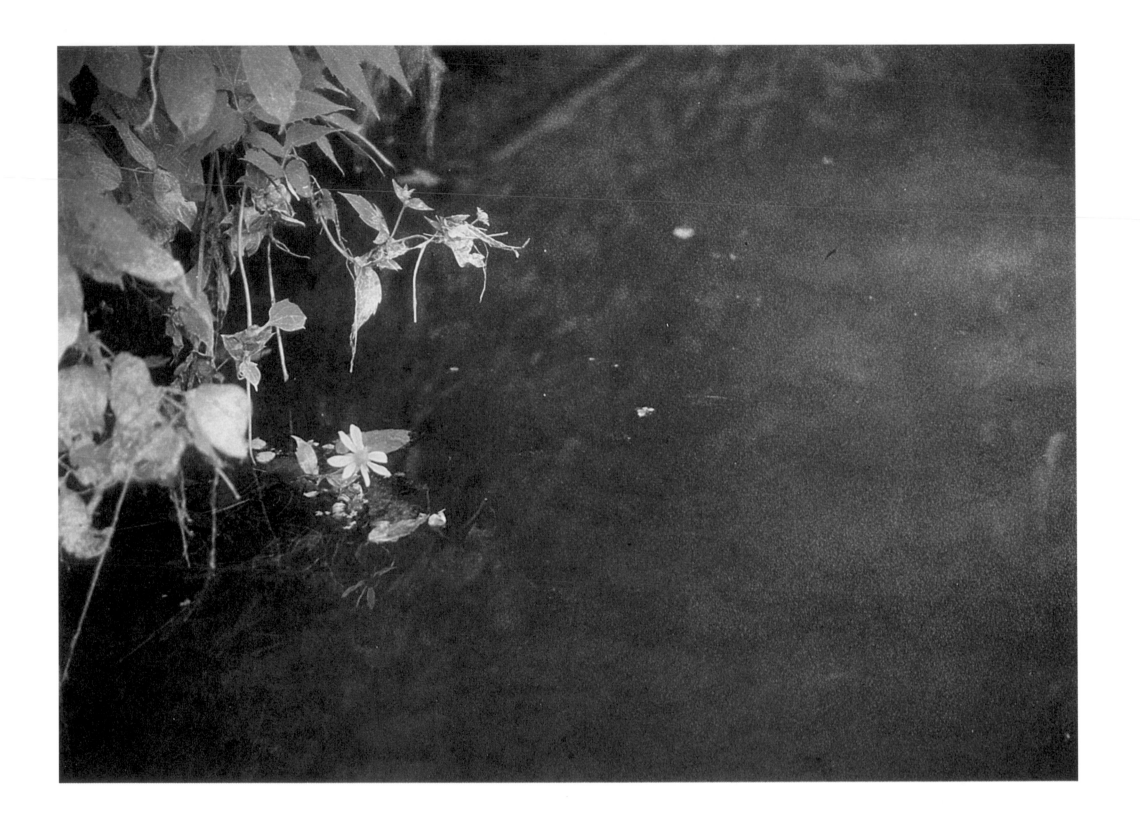

IN SUMMER WE LIVE OUT OF DOORS, AND WE HAVE ONLY IMPULSES
AND FEELINGS, WHICH ARE ALL FOR ACTION, AND MUST WAIT
COMMONLY FOR THE STILLNESS AND LONGER NIGHTS OF AUTUMN
AND WINTER BEFORE ANY THOUGHT WILL SUBSIDE; WE ARE
SENSIBLE THAT BEHIND THE RUSTLING LEAVES, THERE IS THE
FIELD OF A WHOLLY NEW LIFE, WHICH NO MAN HAS LIVED;
THAT EVEN THIS EARTH WAS MADE FOR MORE MYSTERIOUS AND
NOBLER INHABITANTS THAN MEN AND WOMEN.

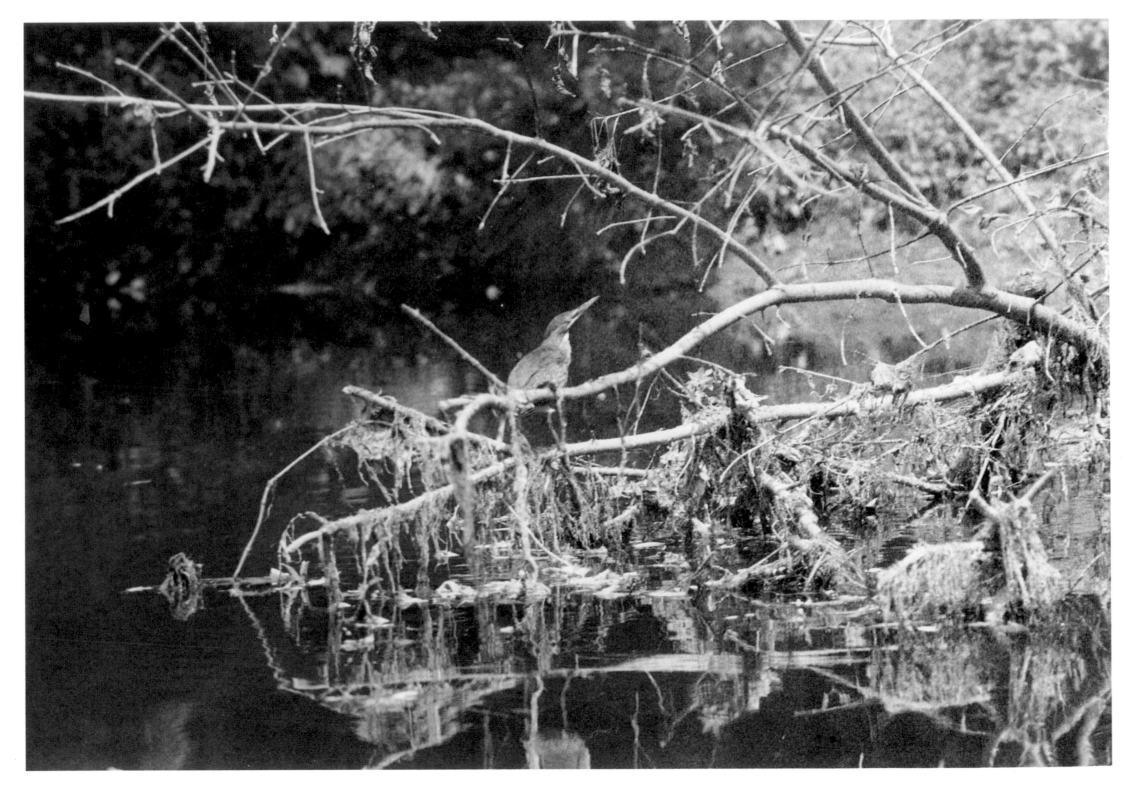

WHEN I WALK IN THE WOODS, I AM REMINDED THAT A WISE
PURVEYOR HAS BEEN THERE BEFORE ME; MY MOST DELICATE
EXPERIENCE IS TYPIFIED THERE. I AM STRUCK WITH THE
PLEASING FRIENDSHIPS AND UNANIMITIES OF NATURE...

TWELVE

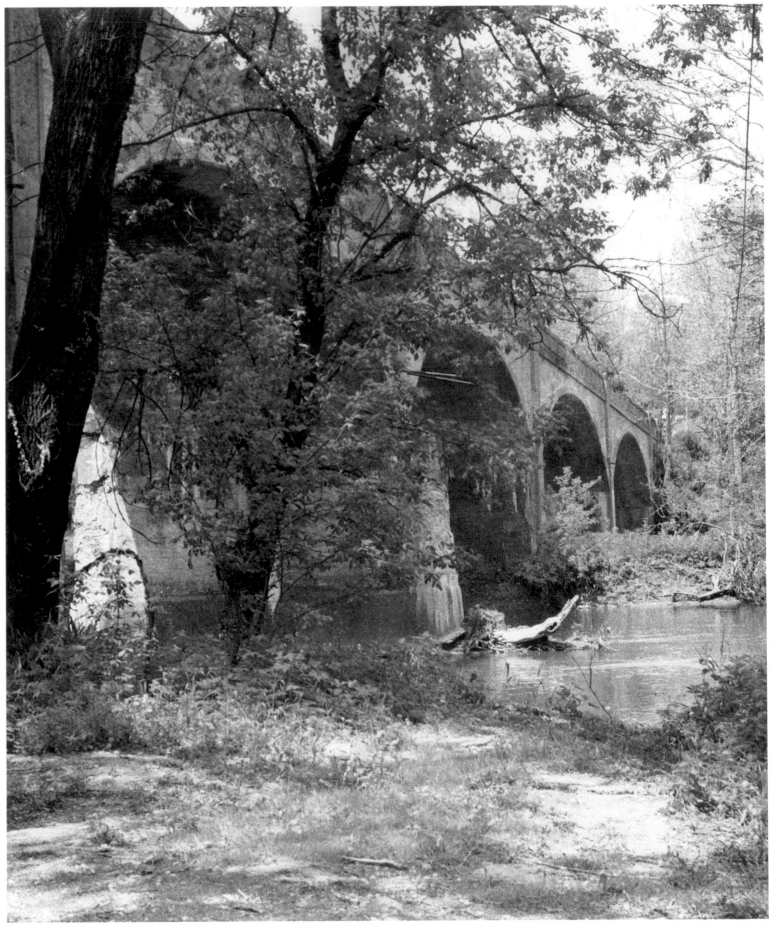

IT IS A BEAUTIFUL ILLUSTRATION OF THE LAW OF OBEDIENCE,
THE FLOW OF A RIVER. ITS SLIGHT OCCASIONAL FALLS,
WHOSE PRECIPICES WOULD NOT DIVERSIFY THE LANDSCAPE...
ATTRACT THE TRAVELER FROM FAR AND NEAR. FROM THE
REMOTE INTERIOR, ITS CURRENT CONDUCTS HIM BY BROAD AND
EASY STEPS, OR BY ONE GENTLER INCLINED PATH, TO THE
SEA. THUS BY AN EARLY AND CONSTANT YIELDING TO THE
INEQUALITIES OF THE GROUND IT SECURES ITSELF THE EASIEST
PASSAGE.

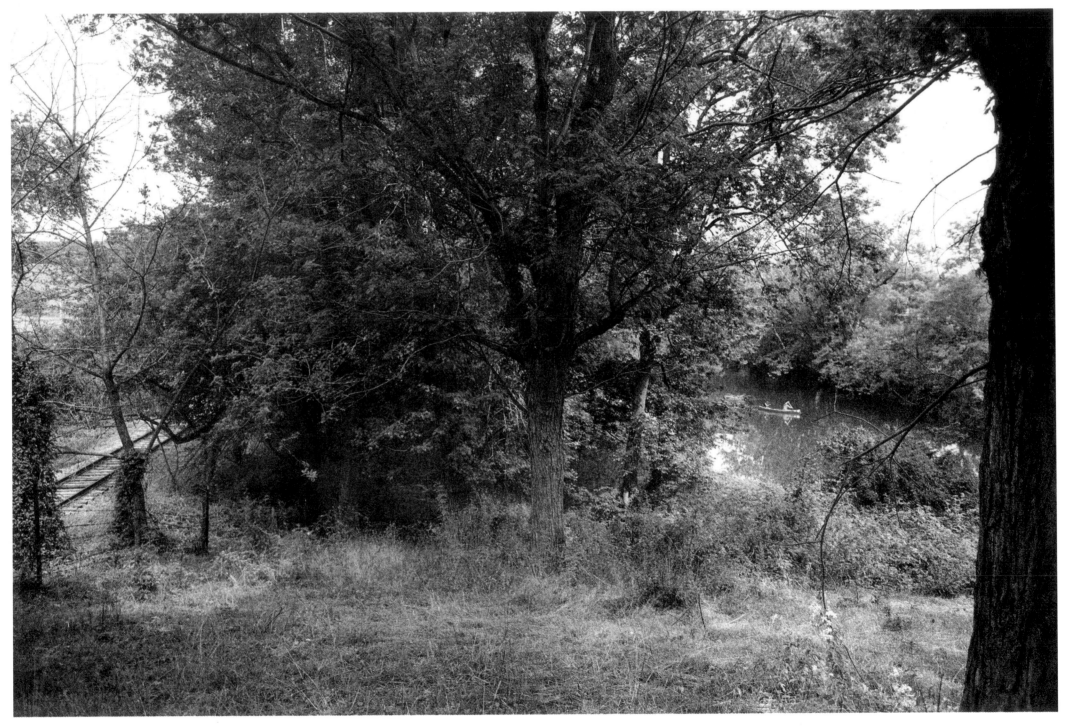

IN THESE WILD SCENES, MEN STAND ABOUT IN THE SCENERY,
...HAVING SACRIFICED THE SPRIGHTLINESS AND VIVACITY
OF TOWNS...

HE DOES NOT MAKE THE SCENERY LESS WILD...BUT STANDS
THERE AS A PART OF IT, AS THE NATIVES ARE REPRESENTED
IN THE VOYAGES OF EARLY NAVIGATORS.

HE BELONGS TO THE NATURAL FAMILY OF MAN, AND IS PLANTED
DEEPER IN NATURE AND HAS MORE ROOT THAN THE INHABITANTS
OF TOWNS. GO ASK HIM WHAT LUCK, AND YOU WILL LEARN
THAT HE TOO IS A WORSHIPPER OF THE UNSEEN.

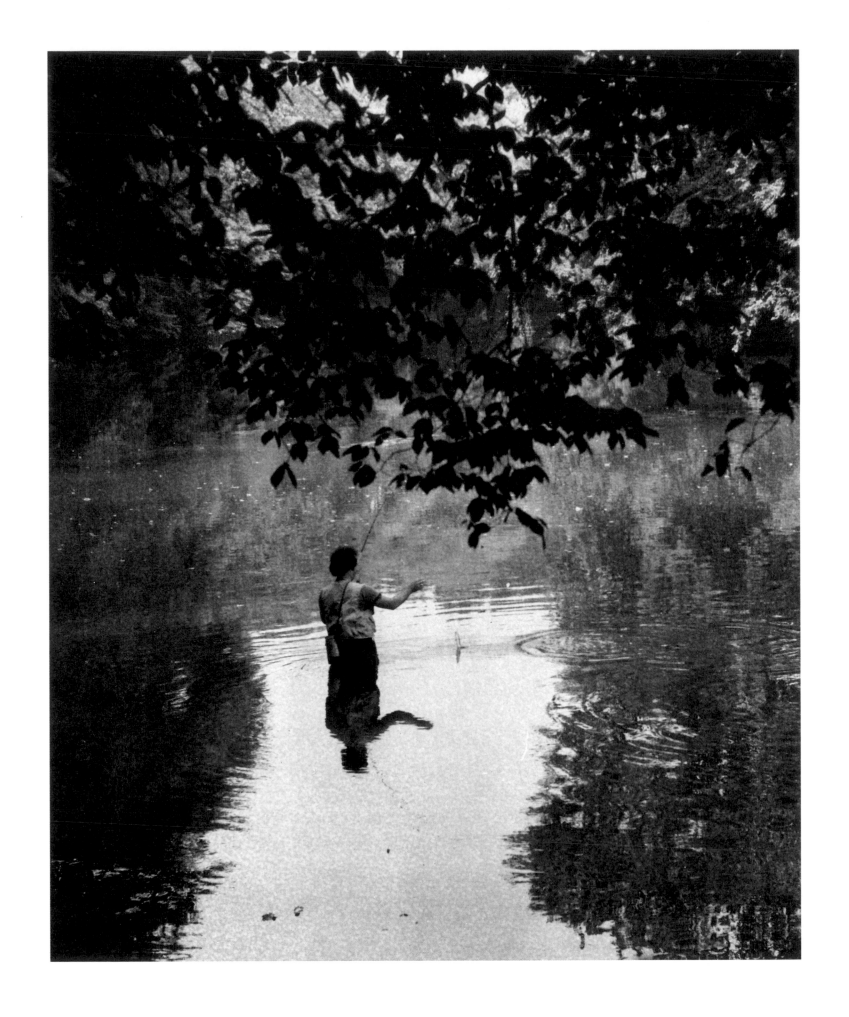

BUT HERE ON THE STREAM,...NATURE, WHO IS SUPERIOR
TO ALL STYLES AND AGES, IS NOW, WITH PENSIVE FACE,
COMPOSING HER POEM AUTUMN...

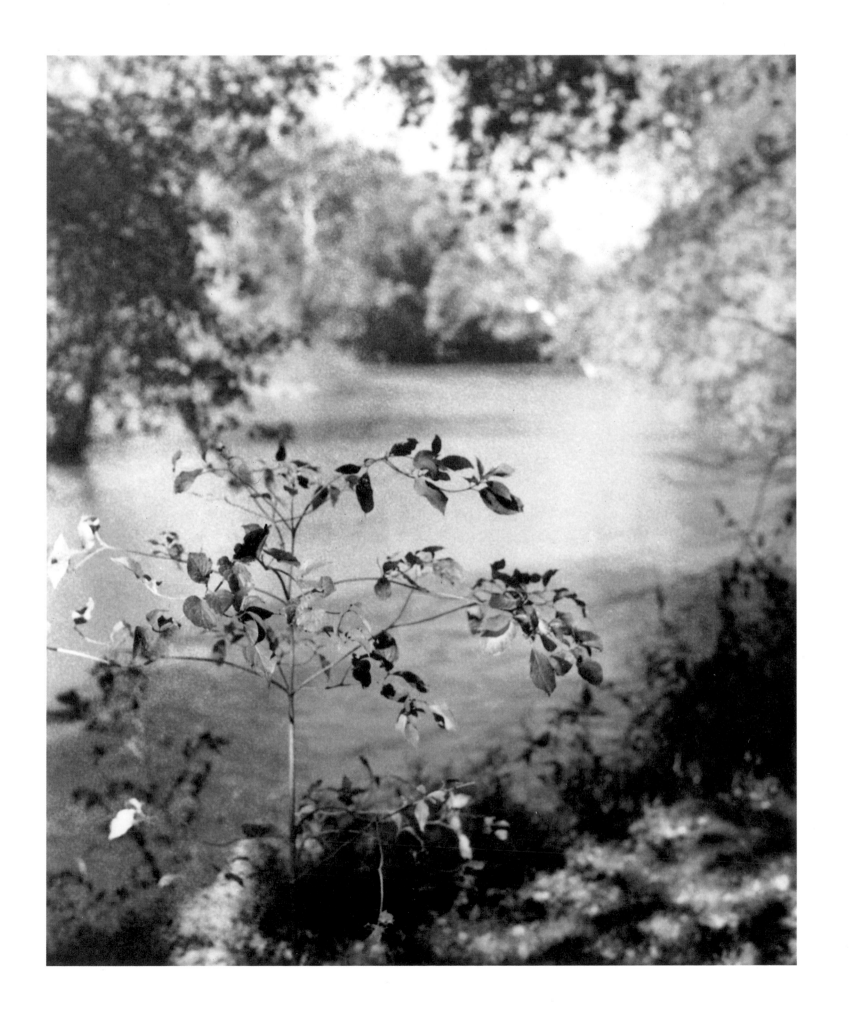

IF ALL WERE AS IT SEEMS, AND MEN MADE THE ELEMENTS
THEIR SERVANTS FOR NOBLE ENDS! IF THE CLOUD THAT
HANGS OVER THE ENGINE WERE THE PERSPIRATION OF HEROIC
DEEDS, OR AS BENEFICENT AS THAT WHICH FLOATS OVER THE
FARMER'S FIELDS, THENTHE ELEMENTS AND NATURE HERSELF
WOULD CHEERFULLY ACCOMPANY MEN ON THEIR ERRANDS AND
BE THEIR ESCORT.

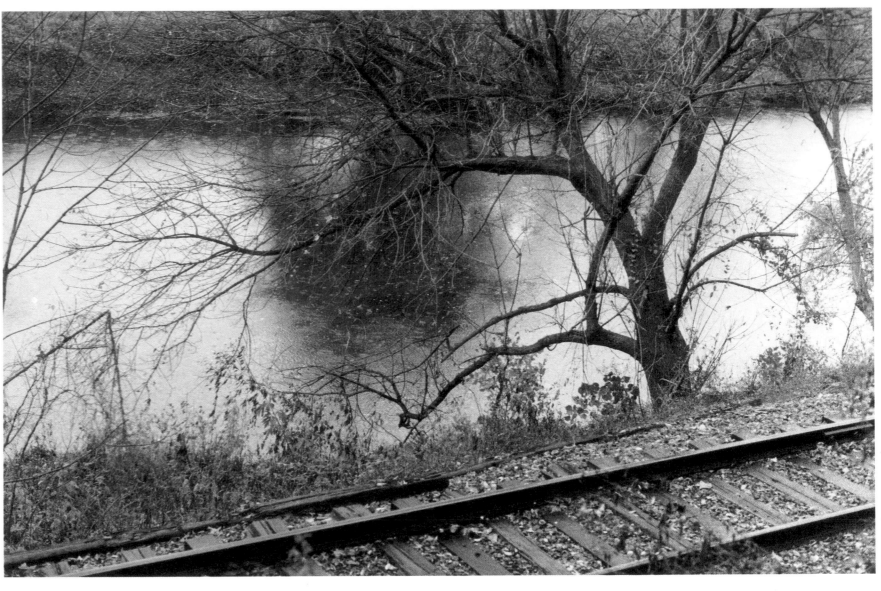

IN THE WINTER, WARMTH STANDS FOR ALL VIRTUE, AND WE RESORT IN THOUGHT TO A TRICKLING RILL, WITH ITS BARE STONES SHINING IN THE SUN, AND TO WARM SPRINGS IN THE WOODS...

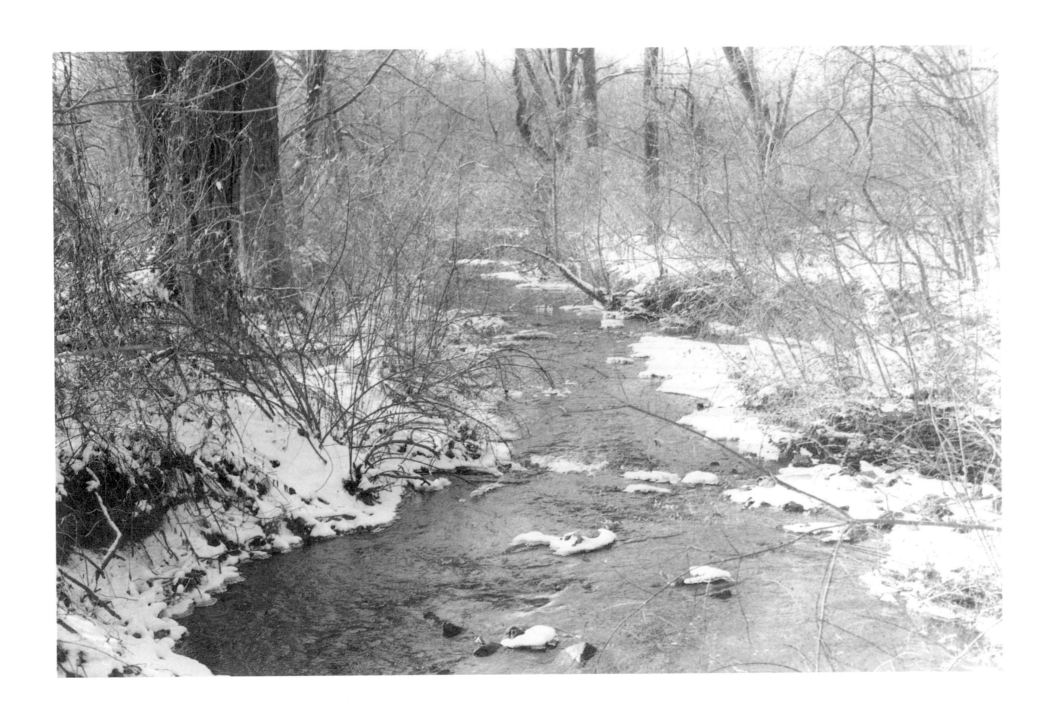

BEFORE NIGHT WE WILL TAKE A JOURNEY ON SKATES ALONG
THE COURSE OF THIS MEANDERING RIVER, AS IF IT WERE
OVER THE POLAR ICE; FOLLOWING THE WINDING OF THE STREAM,
NOW FLOWING AMID HILLS, NOW SPREADING OUT INTO FAIR
MEADOWS.

TWENTY FOUR

THE RIVER FLOWS IN THE REAR OF THE TOWNS,
AND WE SEE ALL THINGS FROM A NEW AND WILDER SIDE.
IT IS THE OUTSIDE AND EDGE OF THE EARTH.

The Village

The village is the place to which the roads tend, a sort of expansion of the highway... It is the body of which roads are the arms and legs—the thoroughfare and ordinary of travelers.

—Thoreau

In the early 1900s the village of Chadds Ford, Pennsylvania, was composed of a creamery, a blacksmith shop, two railroad stations, a lumber and coal yard, two stores, two churches, a hotel, a barber shop, and a drugstore. Two doctors were in residence. The post office was located at Chadds Ford Junction. Local children attended classes in the area's one-room schoolhouse. And a dirt road through the center of town was the main thoroughfare and ordinary of travelers.

The original village residents called the town "the Ford." The phrase is used by native residents today. But this small village is presently in a state of transition and preservation. Restoration and conservation are the main concerns of local citizens. Sentiment and respect for village customs and its history guide community decisions that determine present-day village activities.

Changing times have been responsible for the changing face of the village. The old dirt road through the center of town has become a paved, fourlane highway. A modern post office, a convenience store, and a complex of boutique and antique shops is a community response to the growth of the village and an expanding tourist interest in the area. The blacksmith shop, the general store, the covered bridge, and the one-room schoolhouse are part of a past which this world will never see again. The old ways, like the old local heroes, have long since passed away.

The homes of several of the village's earliest settlers have been restored and placed on the National Register of Historic Places. The John Chadd House and the Barnes Brinton House are open to the public with tours conducted by volunteer members of the local Historical Society. The home of Christian Sanderson, historian and local school teacher, is a village museum and treasure house of memorabilia on the Battle of Brandywine. The battlefield itself is a meticulously maintained state park. And a flour mill along the river that operated until the early 1940s has been converted into the Brandywine River Museum. Represented here are the art of three generations of Wyeth family members and an extensive collection of paintings and illustrations by outstanding American artists.

Sentiment and respect for the past will always be the link to the future of the Ford. New characters, names, and faces appear on the present scene. Yet they too, will someday take their place in the history of Chadds Ford, Pennsylvania. For one day they will be the old folk, living in a remembered world.

THE VILLAGE IS THE PLACE TO WHICH THE ROADS TEND,
A SORT OF EXPANSION OF THE HIGHWAY...
IT IS THE BODY OF WHICH ROADS ARE THE ARMS AND LEGS–
THE THOROUGHFARE AND ORDINARY OF TRAVELERS.

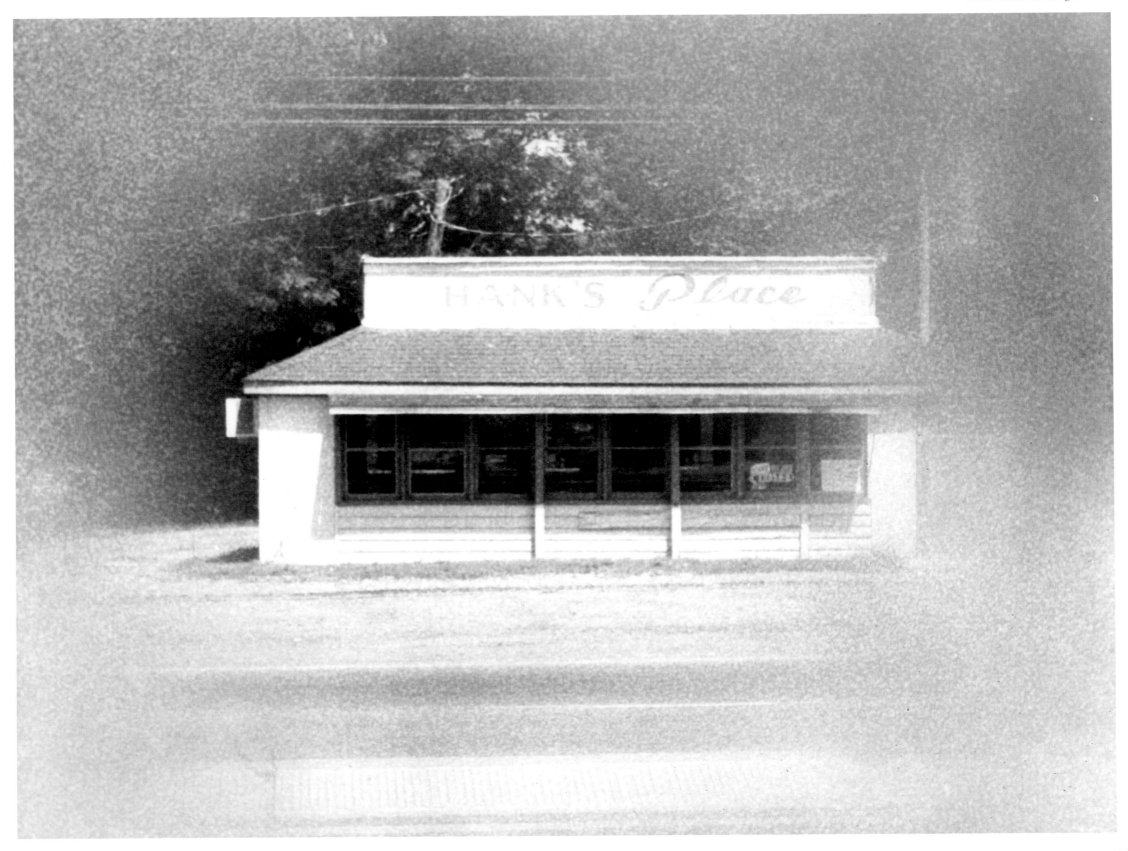

Hanks. The local eatery for resident artists and village folk. Truckers driving the busy corridor of US Route 1 file into Hank Shupe's diner in the early morning hours. Friendly conversation is free with the morning coffee.

AS THE NOBLEMAN OF CULTIVATED TASTE SURROUNDS HIMSELF
WITH WHATEVER CONDUCES TO HIS CULTURE: GENIUS–LEARNING–
WIT–BOOKS–PAINTING–STATUARY–MUSIC–PHILOSOPHICAL
INSTRUMENTS, AND THE LIKE: SO LET THE VILLAGE DO…

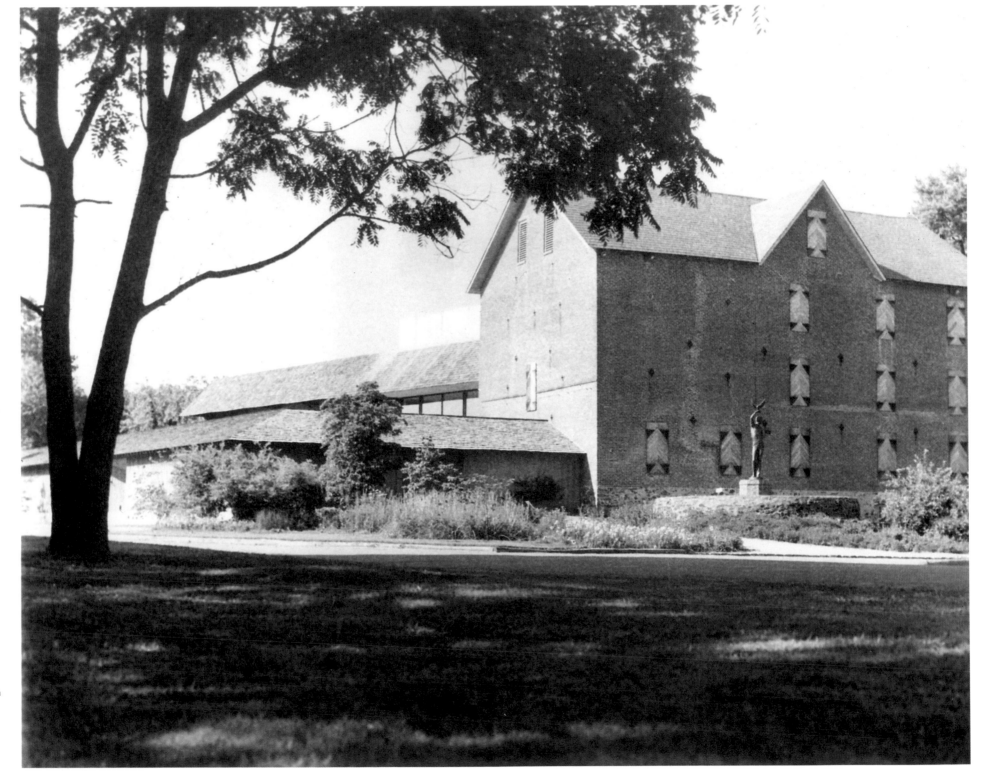

The Brandywine River Museum. A restored 19th-century grist mill on the banks of the Brandywine River houses an extensive collection of Andrew Wyeth's work as well as three generations of Wyeth family paintings. Numerous artists associated with the Brandywine Tradition in painting, as well as other American artists and illustrators, are represented in year-round exhibitions. In 1984 a new wing was added to the museum structure.

...TO ACT COLLECTIVELY IS ACCORDING TO THE SPIRIT OF OUR INSTITUTIONS: AND I AM CONFIDENT THAT, AS OUR CIRCUMSTANCES ARE MORE FLOURISHING, OUR MEANS ARE GREATER THAN THE NOBLEMAN'S. INSTEAD OF NOBLEMEN, LET US HAVE NOBLE VILLAGES OF MEN.

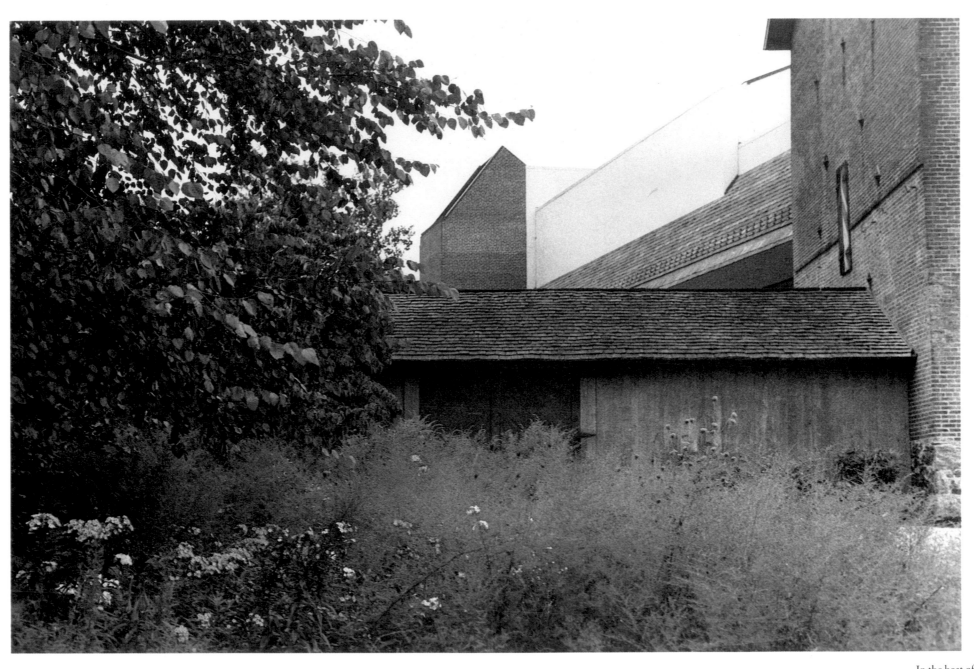

In the heat of a summer's evening, long after crowds of tourists have passed through its doors, the museum stands as a silent presence in the history of the valley: a reminder of the past, preserved in the present, ensuring a future for the treasures within its walls.

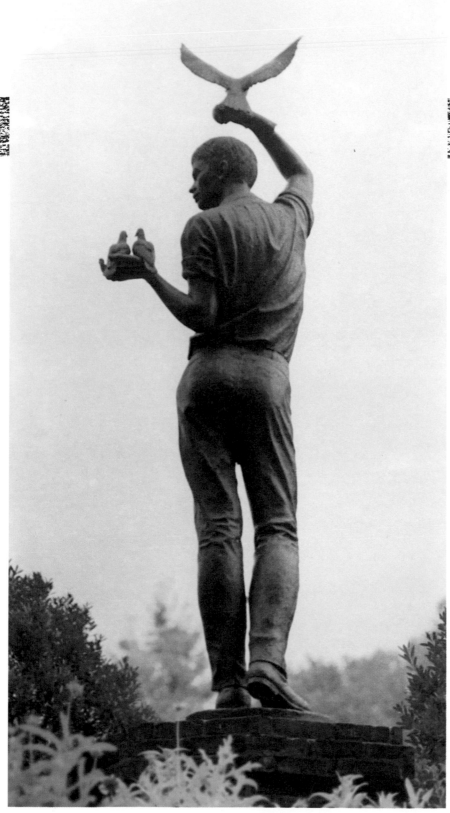

"Boy with Hawk." Sculpture in bronze incorporated into the museum landscape. Charles Parks, sculptor.

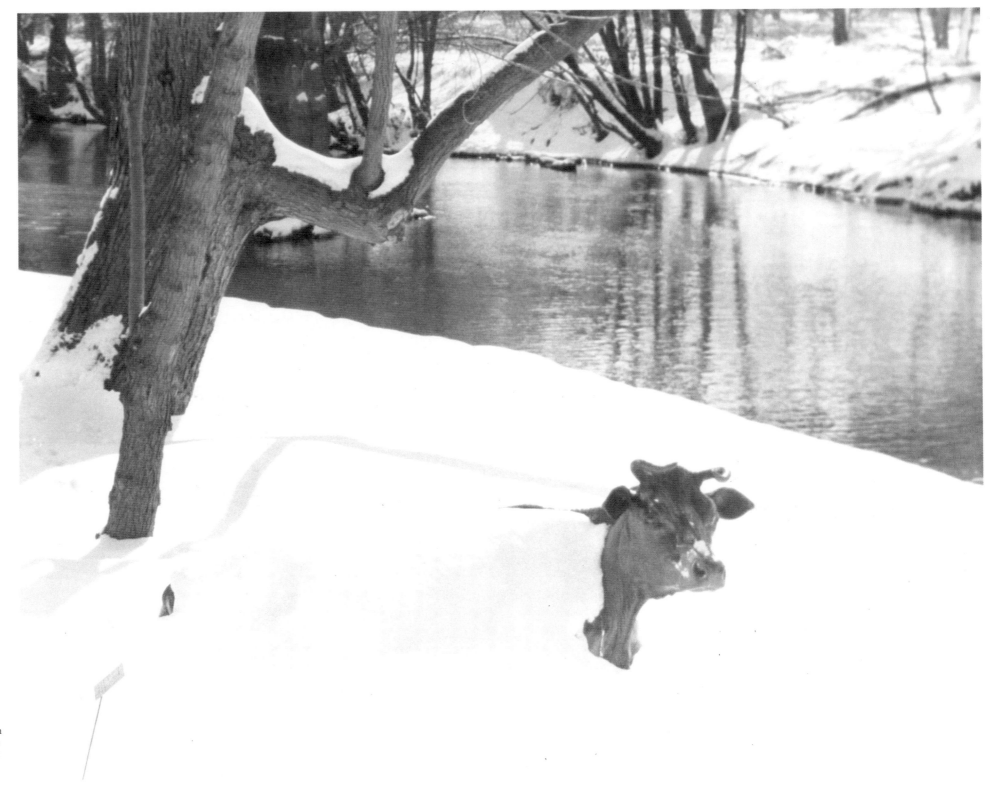

"Miss Gratz." Sculpture in bronze, reclining along the riverbank, under a blanket of snow. J. Clayton Bright, sculptor.

OUR VILLAGE LIFE WOULD STAGNATE IF IT WERE NOT FOR
THE UNEXPLORED FORESTS AND MEADOWS WHICH SURROUND IT.
WE NEED THE TONIC OF WILDNESS.

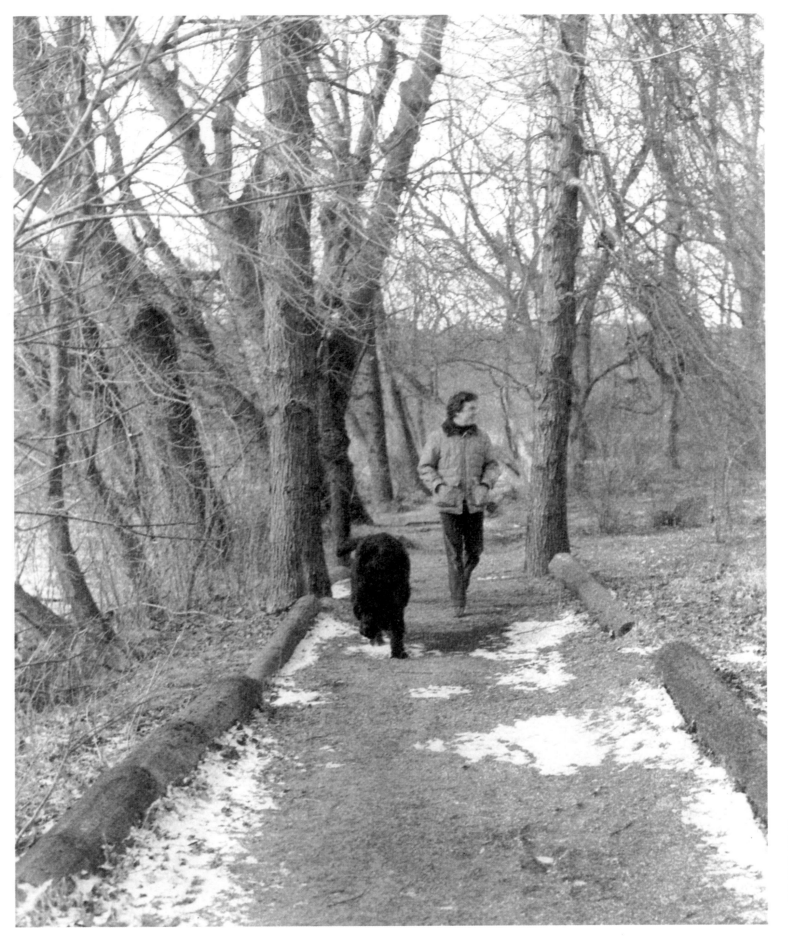

The artist's son, Jamie Wyeth, and his Newfoundland dog, "Boom-Boom," along the woodland path behind the museum. The artist is the third generation of Wyeths to bring artistic vision to the Brandywine Valley.

NATURE IS PREPARED TO WELCOME INTO HER SCENERY THE FINEST WORK OF HUMAN ART, FOR SHE IS HERSELF AN ART SO CUNNING THAT THE ARTIST NEVER APPEARS IN HIS WORK.

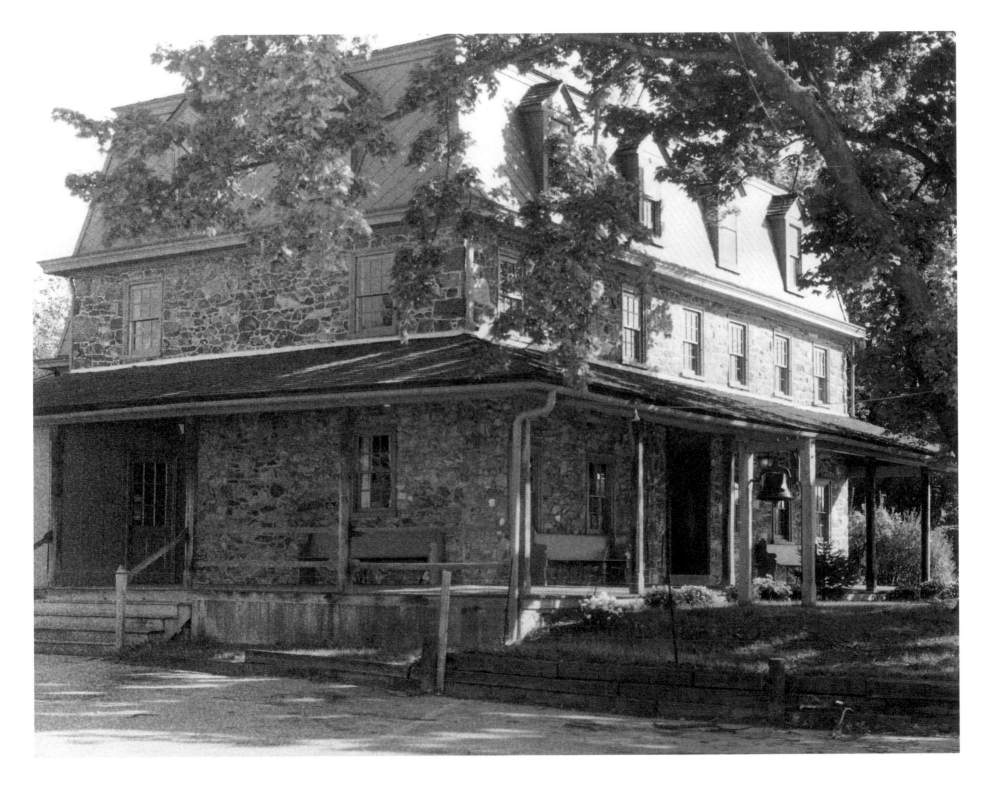

The Chadds Ford Inn. Village history is preserved in this structure of warm, brown stone. Originally the home of Frances Chadsey, whose son, John Chadd, owned and operated the first documented ferry across the Brandywine River.

...THIS AUTUMNAL FESTIVAL, WHEN MEN ARE GATHERED IN
CROWDS IN THE STREETS AS REGULARLY AND BY AS NATURAL
A LAW AS THE LEAVES CLUSTER AND RUSTLE BY THE WAYSIDE,
IS NATURALLY ASSOCIATED IN MY MIND WITH THE FALL OF THE
YEAR. THESE ARE STIRRING AUTUMN DAYS; THIS IS THE TRUE
HARVEST OF THE YEAR...HOW NATURAL AND IRREPRESSIBLE
IN EVERY PEOPLE IS SOME HEARTY AND PALPABLE GREETING
OF NATURE!

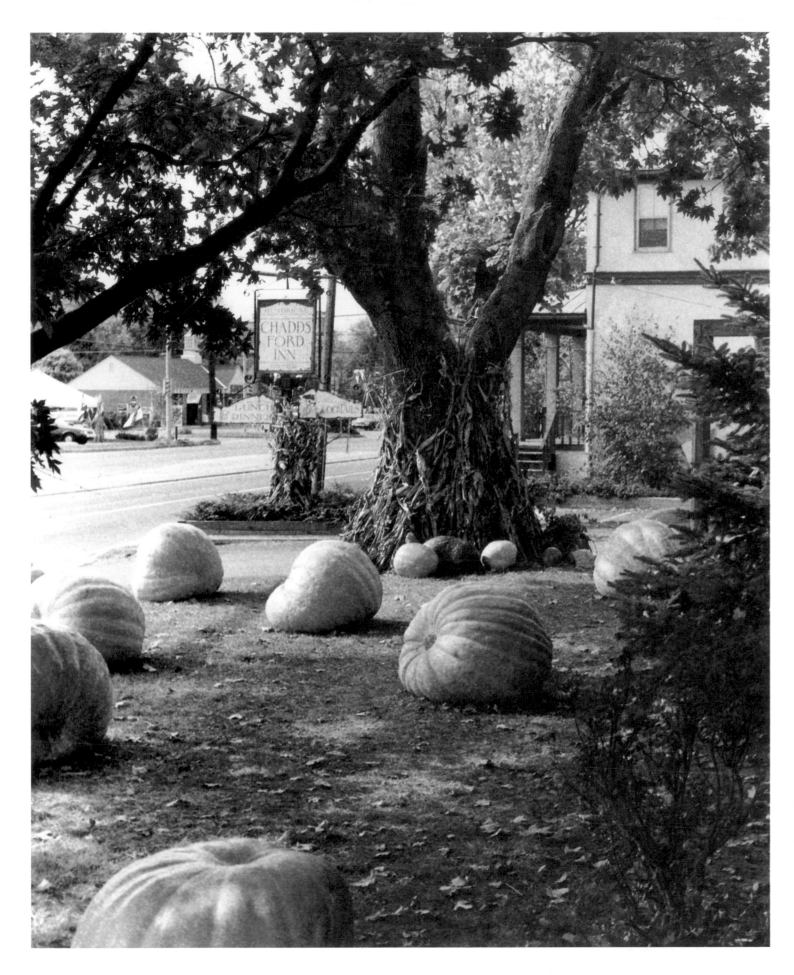

October. The front lawn of the Chadds Ford Inn is the scene of an annual pumpkin-carving contest. Many of the local artists and craftsmen compete. The word around the village is that the Wyeths always win.

THE MOST STUPENDOUS SCENERY CEASES TO BE SUBLIME WHEN
IT BECOMES DISTINCT, OR IN OTHER WORDS, LIMITED, AND
THE IMAGINATION IS NO LONGER ENCOURAGED TO EXAGGERATE
IT. NATURE IS NOT MADE AFTER SUCH A FASHION AS WE
WOULD HAVE HER. WE PIOUSLY EXAGGERATE HER WONDERS...

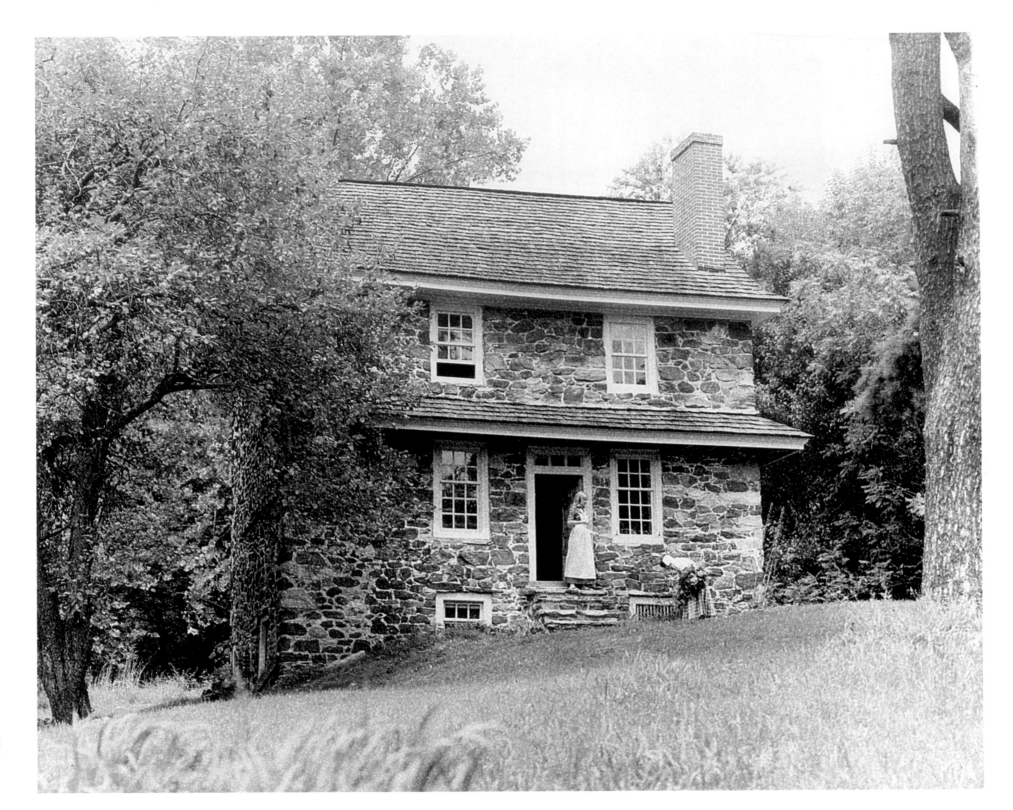

The John Chadd House. The restored home of the owner and operator of the first ferry across the Brandywine. The village became identified by Chadd's fording place on the river, and the town, originally called Birmingham, became known as Chadds Ford.

The small stone building appears in the distance of a 1947 tempera by the artist titled "Hoffman's Slough."

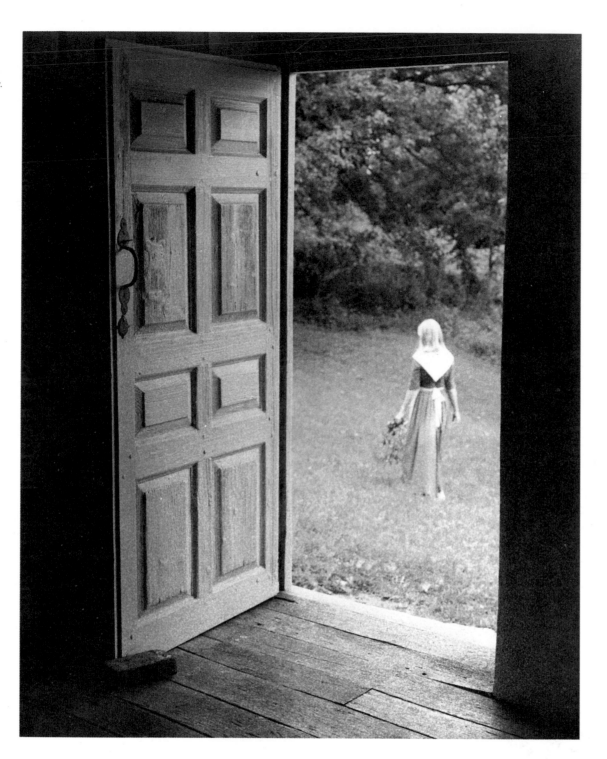

TO HIM WHO CONTEMPLATES A TRAIT OF NATURAL BEAUTY
NO HARM NOR DISAPPOINTMENT CAN COME.

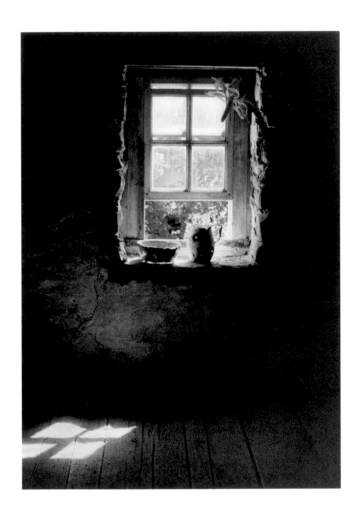

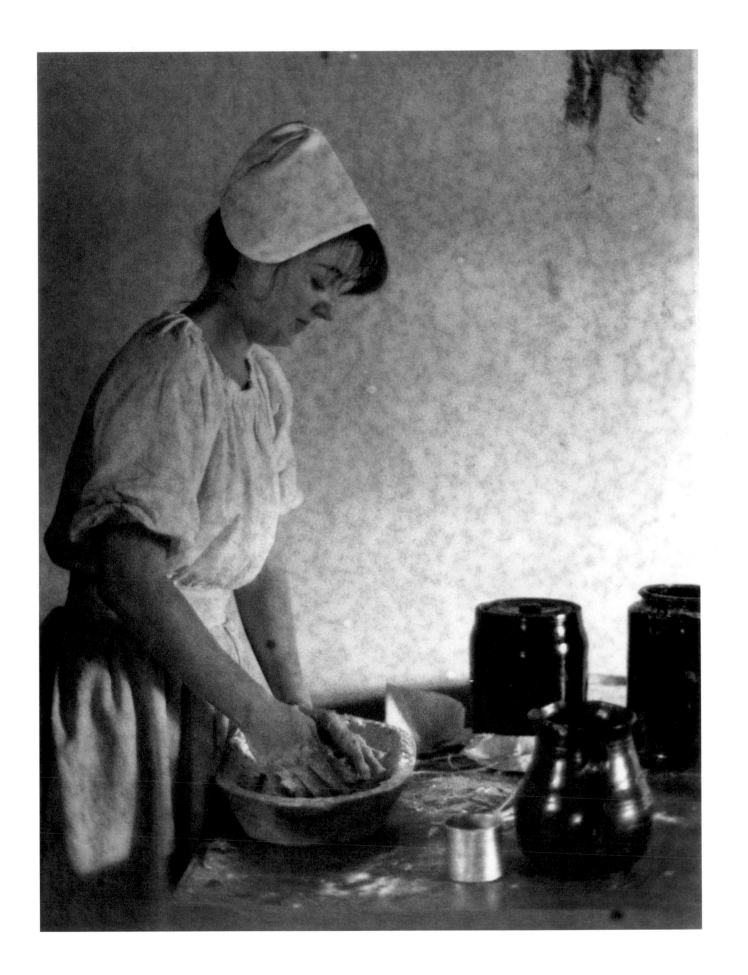

NATURE IS A GREATER AND MORE PERFECT ART, THE ART OF
GOD; REFERRED TO HERSELF, SHE IS GENIUS...
OUR ART LEAVES ITS SHAVINGS AND ITS DUST ABOUT; HER
ART EXHIBITS ITSELF EVEN IN THE SHAVINGS AND THE DUST
WHICH WE MAKE.

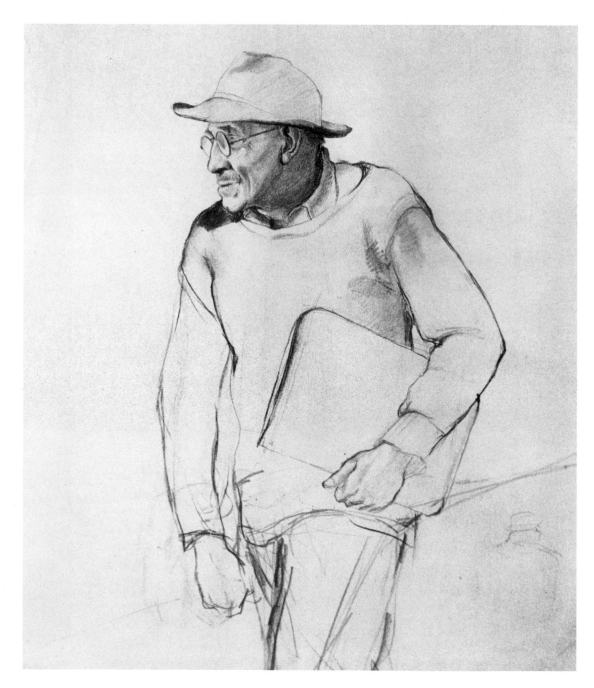

"**Sandy**." Pencil sketch, May,
1945 by Andrew Wyeth.

Courtesy of The Christian C.
Sanderson Museum, Chadds
Ford, Pennsylvania.

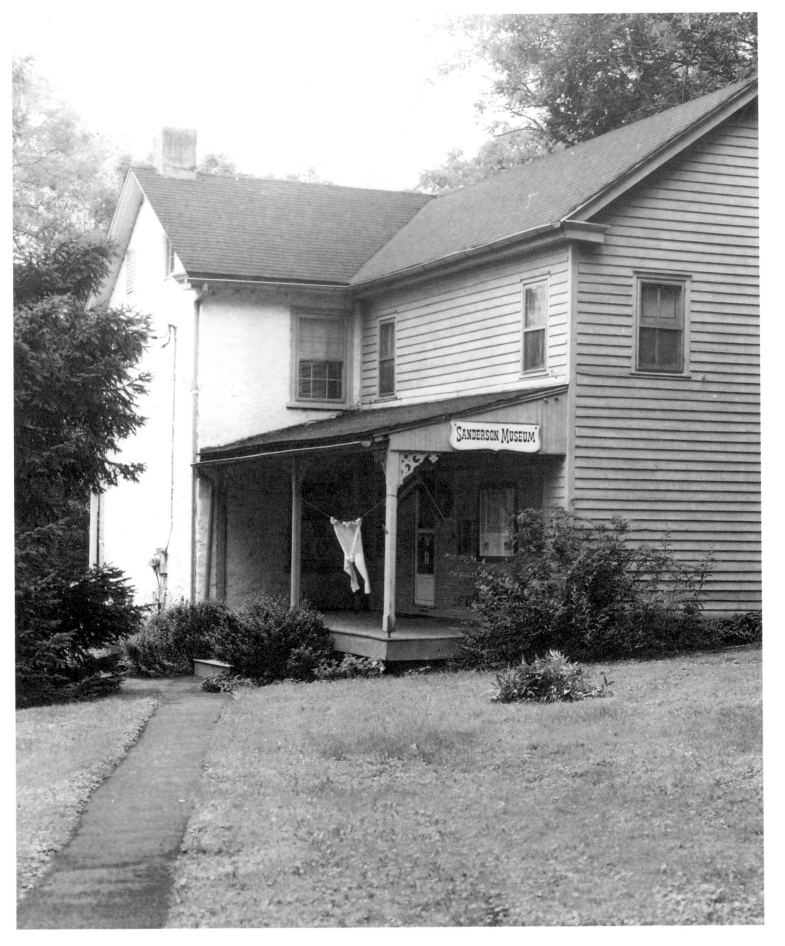

Sanderson Museum. Chris Sanderson was a local bachelor, school teacher, historian, and friend to villagers at the Ford. His great love for history, particularly the facts surrounding The Battle of Brandywine, led to a collection of memorabilia that fills his house, which today stands as a museum in the village.

His hanging shirt was the subject of a watercolor by Andrew Wyeth in 1964 titled "The Bachelor.'"

"Sandy" is a pencil sketch of Chris Sanderson made by Wyeth in 1945.

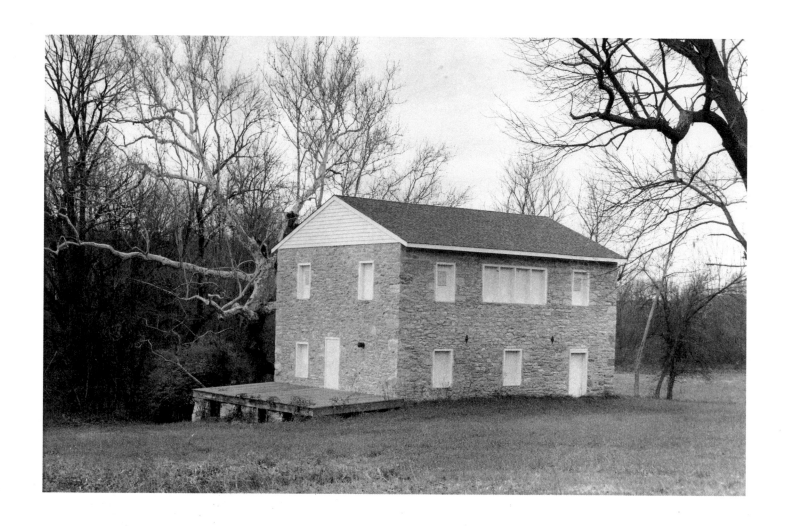

SILENCE IS THE UNIVERSAL REFUGE...SHE IS TRUTH'S
SPEAKING TRUMPET...FOR THROUGH HER ALL REVELATIONS
HAVE BEEN MADE, AND JUST IN PROPORTION AS MEN HAVE
CONSULTED HER ORACLE WITHIN, THEY HAVE OBTAINED A
CLEAR INSIGHT, AND THEIR AGE HAS BEEN MARKED AS AN
ENLIGHTENED ONE.

Before settling his family in their own home in Chadds Ford, N.C. Wyeth rented in the village. Today, one of those residences stands restored. The property is privately owned; the classic illustrations produced in the carriage house that served as N.C. Wyeth's studio remain treasures in American art and literature.

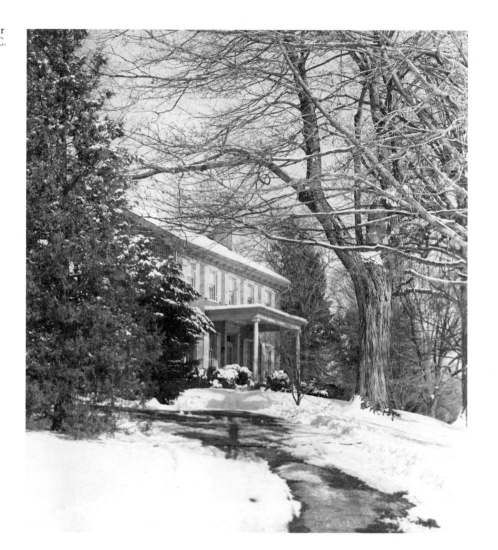

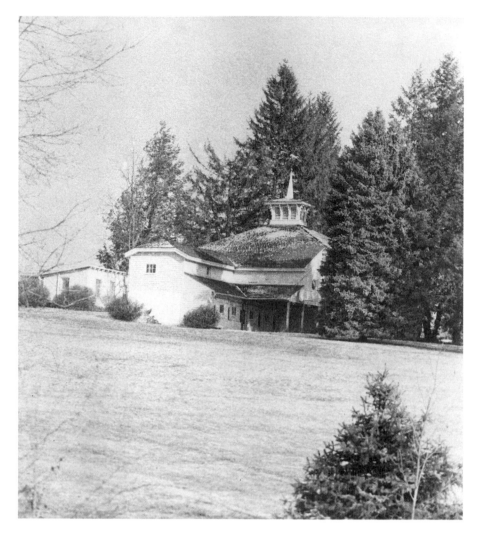

I LEARNED THIS, AT LEAST...THAT IF ONE ADVANCES CONFIDENTLY IN THE DIRECTION OF HIS DREAMS, AND ENDEAVORS TO LIVE THE LIFE WHICH HE HAS IMAGINED, HE WILL MEET WITH A SUCCESS UNEXPECTED IN COMMON HOURS. HE WILL PUT SOME THINGS BEHIND, WILL PASS AN INVISIBLE BOUNDARY; NEW, UNIVERSAL, AND MORE LIBERAL LAWS WILL BEGIN TO ESTABLISH THEMSELVES AROUND AND WITHIN HIM; OR THE OLD LAWS BE EXPANDED...AND HE WILL LIVE WITH THE LICENSE OF A HIGHER ORDER OF BEINGS.

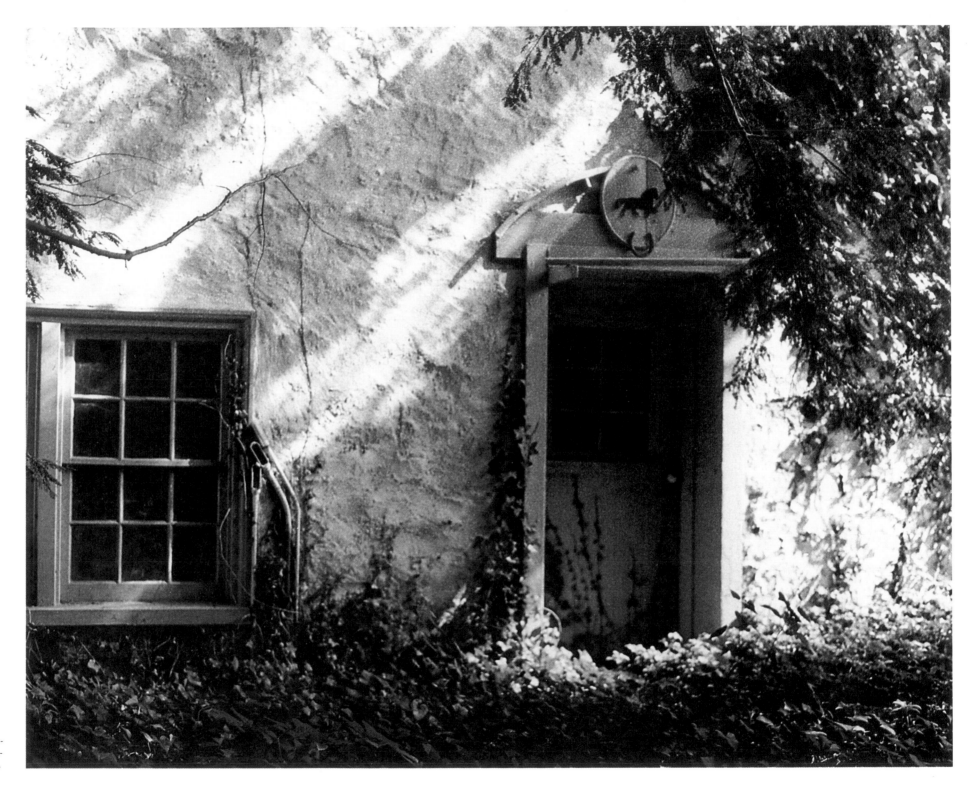

The carriage house in summer where the artist's father, N.C. Wyeth, completed the commissioned illustrations for the children's classic, *Treasure Island*.

THE FORMS OF BEAUTY FALL NATURALLY AROUND THE PATH
OF HIM WHO IS IN THE PERFORMANCE OF HIS PROPER WORK.

ALL THE WORLD REPOSES IN BEAUTY TO HIM WHO PRESERVES
EQUIPOISE IN HIS LIFE, AND MOVES SERENELY ON HIS PATH.

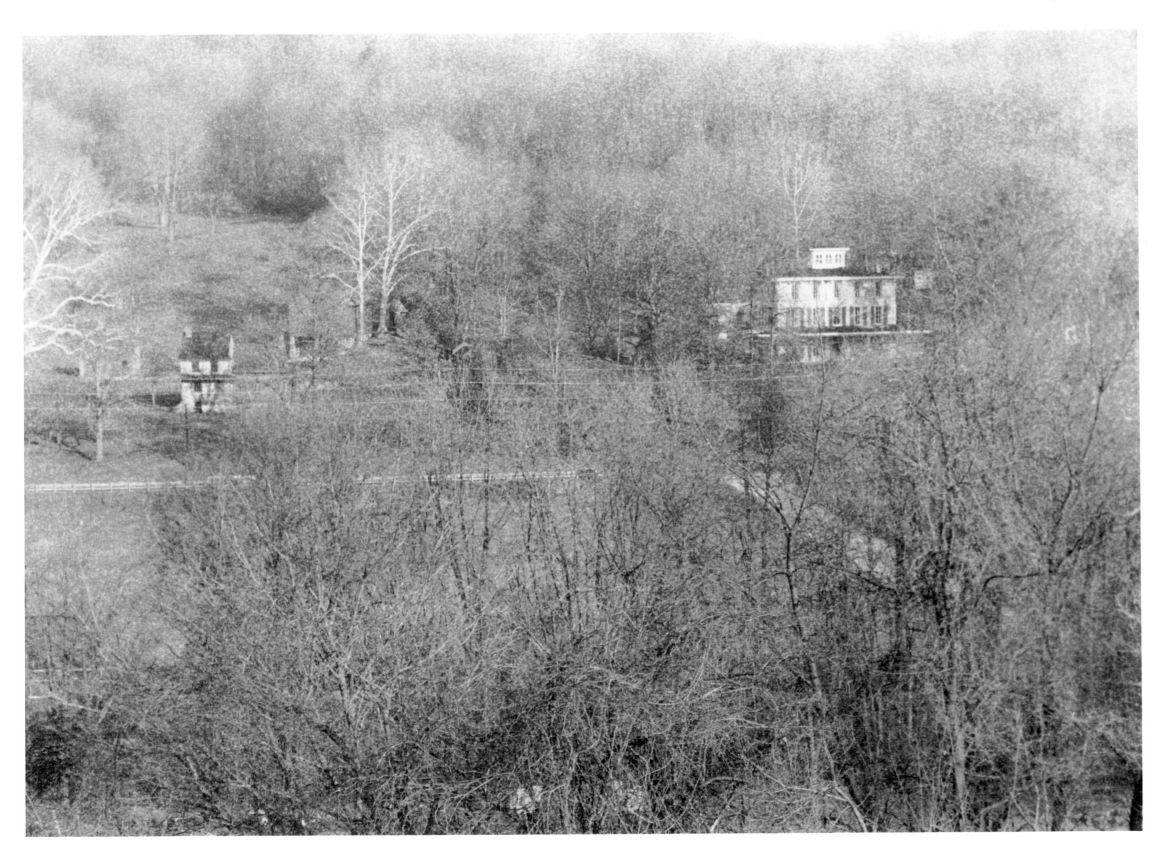

I HEARING GET, WHO HAD BUT EARS,
 AND SIGHT, WHO HAD BUT EYES BEFORE;
I MOMENTS LIVE, WHO LIVED BUT YEARS,
 AND TRUTH DISCERN, WHO KNEW BUT LEARNING'S LORE.

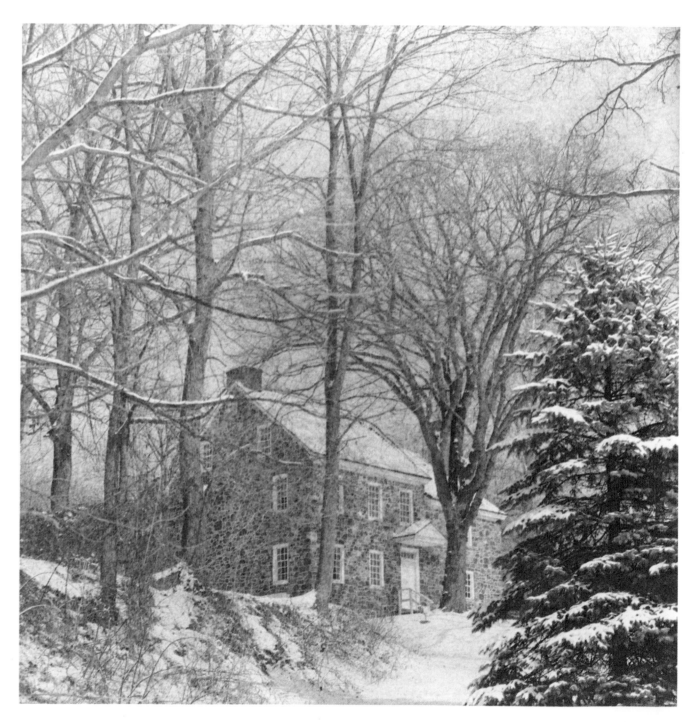

Washington's Headquarters.
The home of Chadds Ford
farmer Benjamin Ring became
the headquarters of General
George Washington during the
Battle of Brandywine in Septem-
ber 1777. The historical associa-
tions of the area were a strong
attraction for the artist's father,
who by 1908 had settled his
family in Chadds Ford.

The Brandywine Battlefield State Park. Two centuries ago, blood was spilled on this soil in the cause of American independence. More than thirty years have passed since the land, once privately owned, passed into state hands.

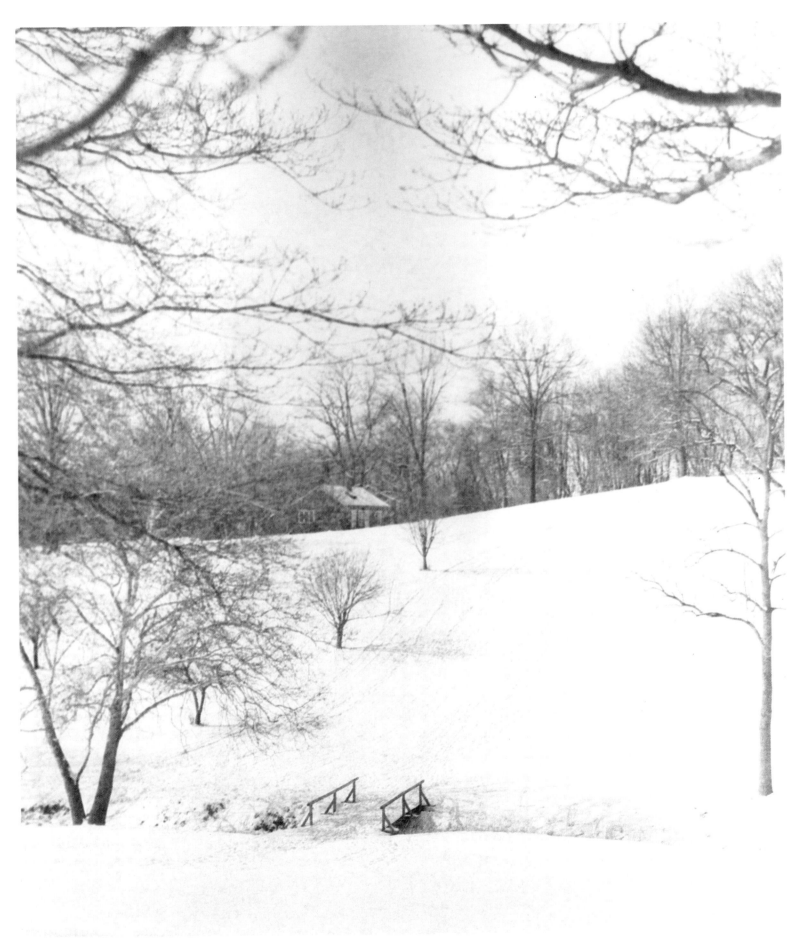

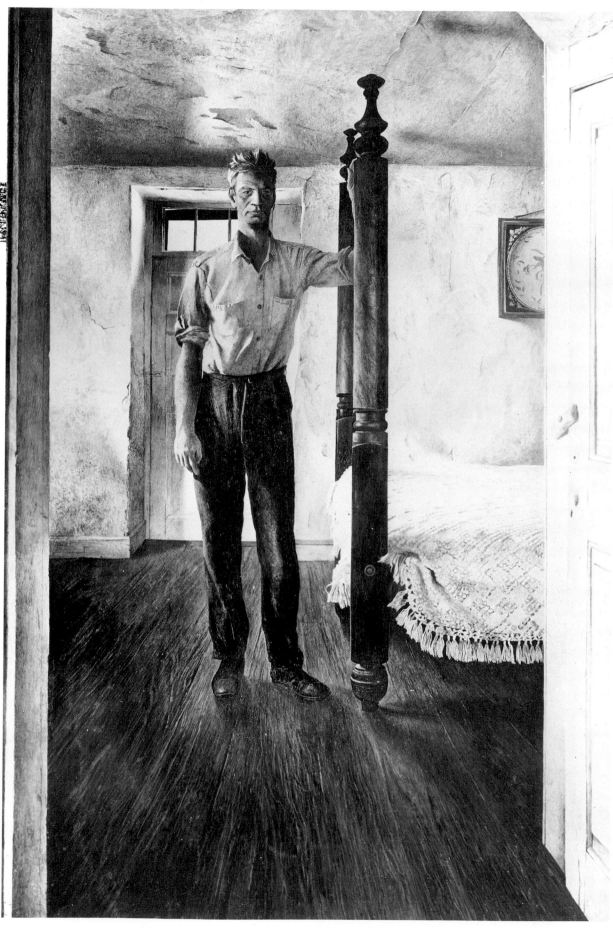

"Arthur Cleveland." Tempera, 1946 by Andrew Wyeth.

Courtesy of The Delaware Art Museum, Wilmington, Delaware.

Lafayette Quarters. The twenty-year-old Marquis de Lafayette fought with General Washington in the Battle of Brandywine. His quarters were on private property which today is part of the battlefield park.

Legend recreates the scene of a wounded Lafayette, leaning against the sycamore tree that stands next to the solid stone building, while viewing the British victory.

The building and the sycamore have appeared in Wyeth paintings.

While the quarters were still in private ownership, the artist chose one of the owners, Arthur Cleveland, for the subject of a tempera painting in 1946.

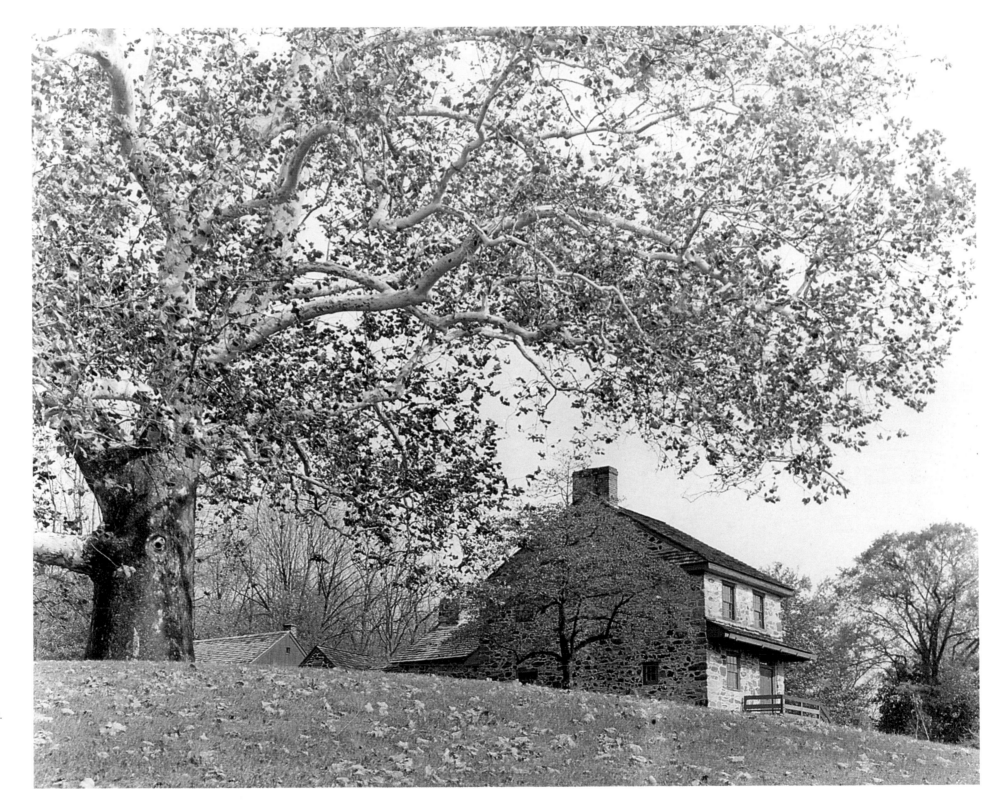

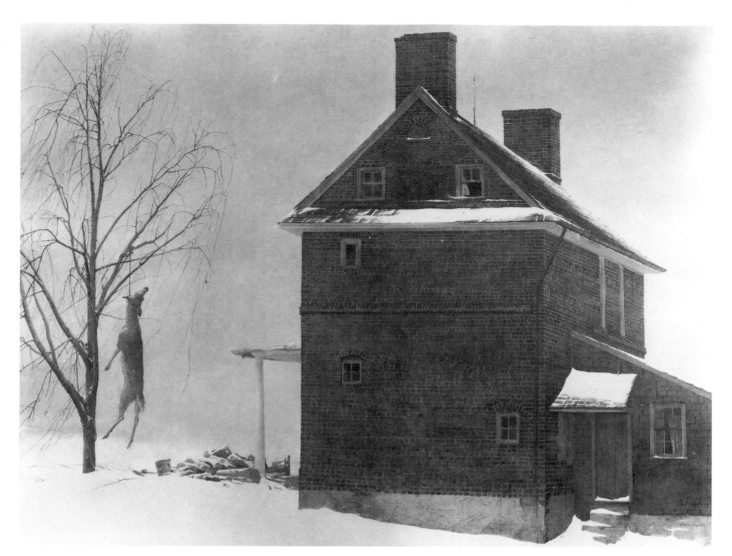

"Tenant Farmer." Tempera, 1961 by Andrew Wyeth.

Courtesy of The Delaware Art Museum, Wilmington, Delaware.

I KNOW OF NO MORE ENCOURAGING FACT THAN THE UNQUESTIONABLE
ABILITY OF MAN TO ELEVATE HIS LIFE BY A CONSCIOUS ENDEAVOR.
IT IS SOMETHING TO BE ABLE TO PAINT A PARTICULAR PICTURE...
BUT IT IS FAR MORE GLORIOUS TO PAINT THE VERY ATMOSPHERE
AND MEDIUM THROUGH WHICH WE LOOK.

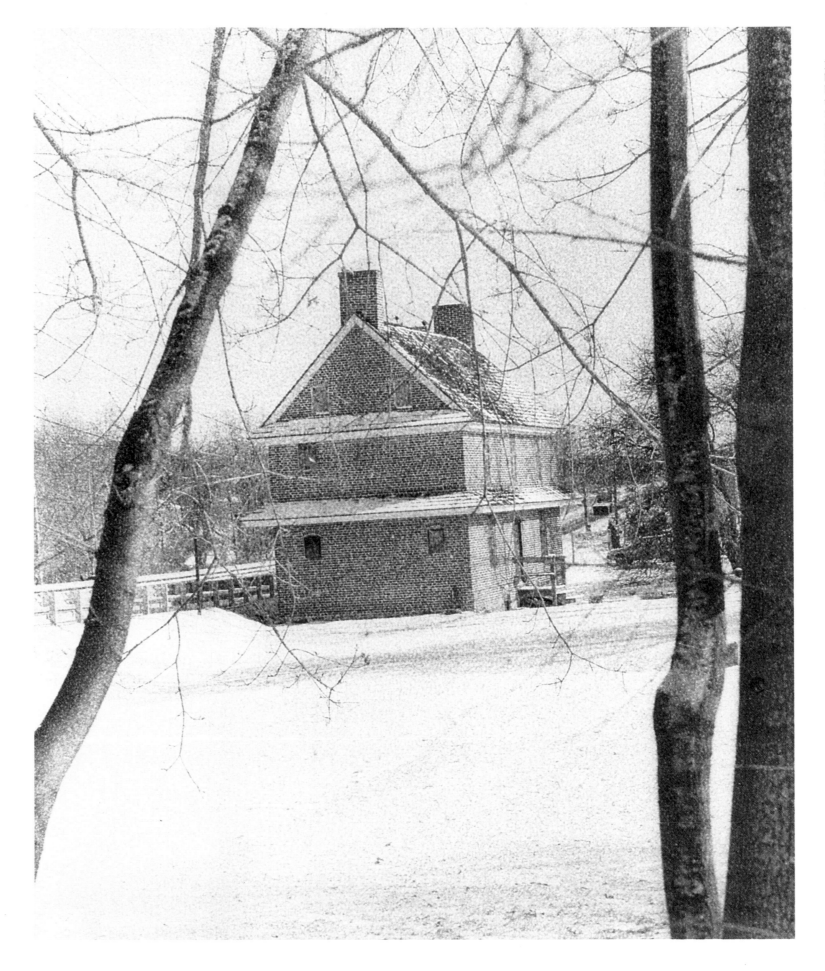

Barnes Brinton House. The red brick home which is said to date back to the time of William Penn was in private ownership when the artist completed the tempera painting "Tenant Farmer" in 1961. Today the Chadds Ford Historical Society maintains the dwelling that once served as a tavern and lodging place for travelers on the road to Nottingham.

THE MOST INTERESTING DWELLINGS IN THIS COUNTRY…ARE
THE MOST UNPRETENDING, HUMBLE COTTAGES OF THE POOR;…
IT IS THE LIFE OF THE INHABITANTS WHOSE SHELLS THEY ARE,
AND NOT ANY PECULIARITY IN THEIR SURFACES MERELY, WHICH
MAKES THEM *PICTURESQUE…*

WHAT OF ARCHITECTURAL BEAUTY I NOW SEE, I KNOW HAS
GRADUALLY GROWN FROM WITHIN OUTWARD, OUT OF THE NECESSITIES
OF THE INDWELLER…

Dilworthtown. The town above the village of Chadds Ford was once the scene of a cluster of Negro family dwellings now long abandoned. Here the artist found subjects which he would capture in portraits titled "Alexander Chandler" (dry brush, 1955); "Granddaughter" (dry brush, 1956); and "Day of the Fair" (dry brush, 1963).

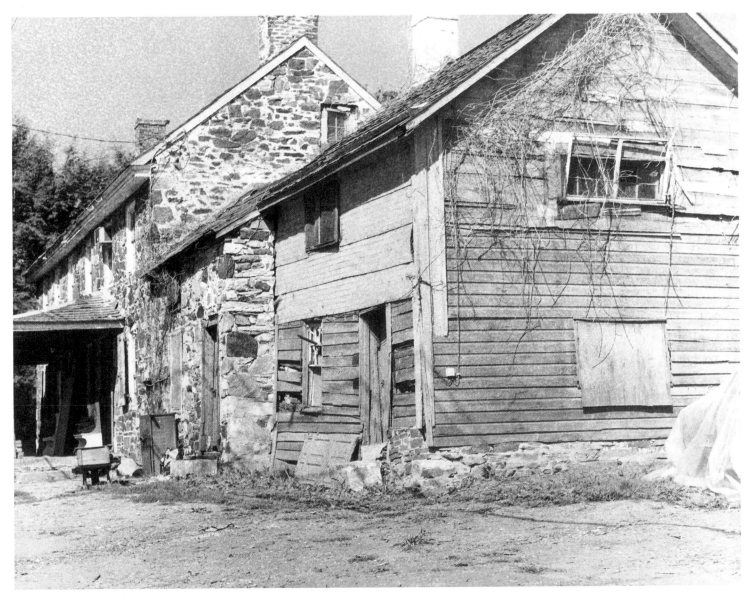

THE TOWN'S POOR SEEM TO ME TO LIVE THE MOST INDEPENDENT
LIVES OF ANY. MAYBE THEY ARE SIMPLY GREAT ENOUGH TO
RECEIVE WITHOUT MISGIVING.

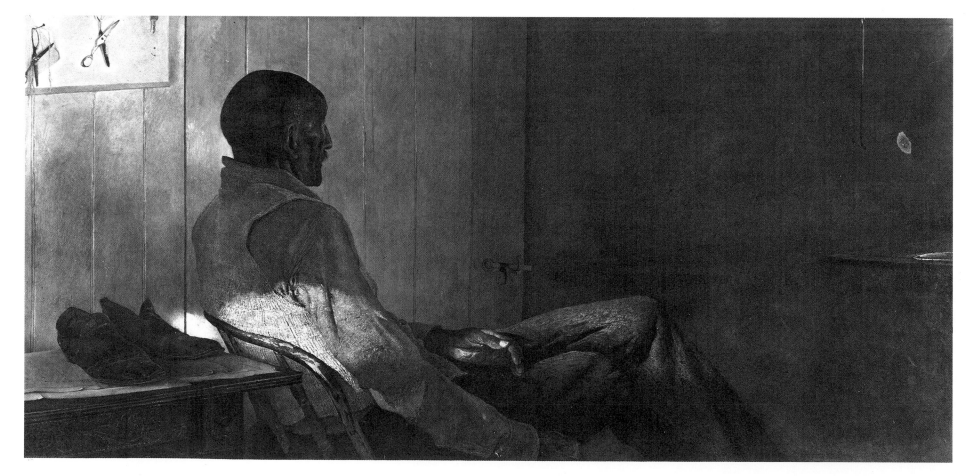

"That Gentleman." Tempera,
1960 by Andrew Wyeth.

Courtesy of The Dallas Museum
of Fine Arts.

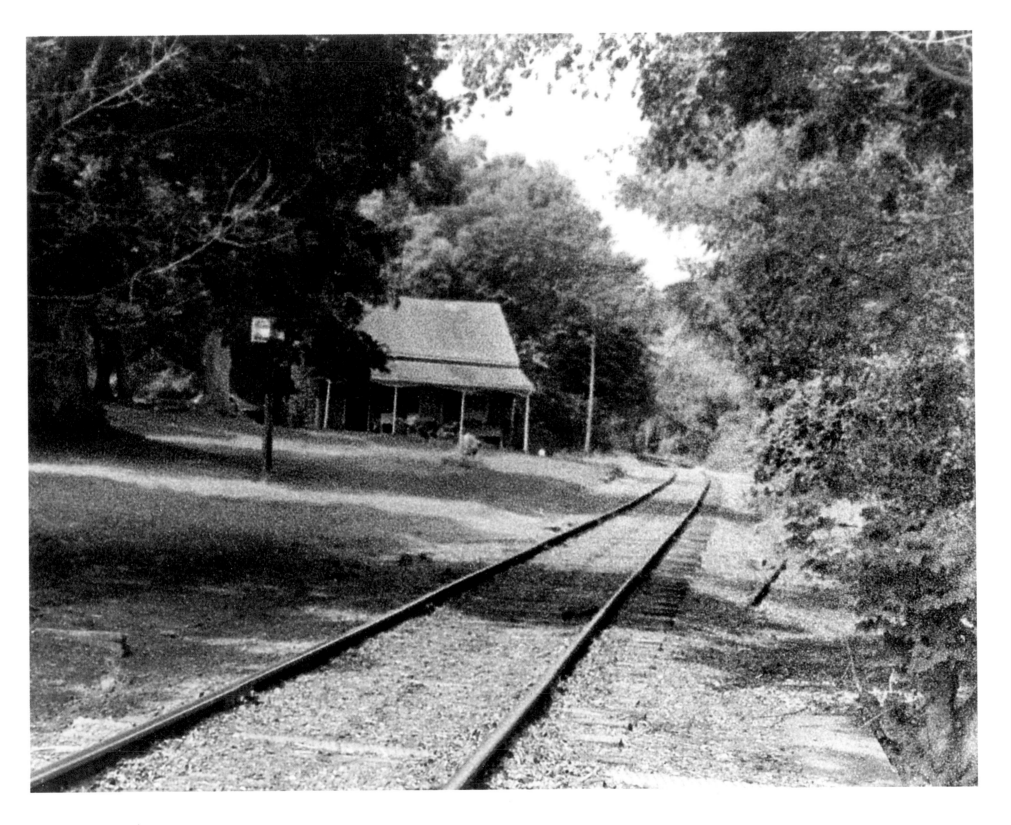

Tom Clark's. The home along the railroad tracks was the residence of one Tom Clark. Clark was a quiet presence in the town, tall and lanky with light blue eyes. He was the subject of several watercolors, temperas, and dry brush paintings by Andrew Wyeth.

The Country

I love to weigh, to settle, to gravitate toward that which most strongly and rightfully attracts me...to travel the only path I can, and that on which no power can resist me.

—Thoreau

N.C. Wyeth was enamored of the countryside in the Brandywine Valley. Its rolling fields and open meadows, wooded hillsides, streams, and farms reminded him of his home in Needham, Massachusetts. He loved the historical associations of the valley and took great pleasure in its peacefulness.

He had come to the country in 1903 as a student in the summer school classes of Howard Pyle. By 1909 he had made the decision to establish his home in Chadds Ford, and two years later he purchased property in the valley. He built a home and a studio, and with his wife, Carolyn, raised his family of five children.

It is from the memories of his childhood, growing up in the countryside of the Brandywine Valley, that Andrew Wyeth derives his deepest love and greatest passion. He has walked the fields and meadows and roamed the hills around his home for more than fifty years. Yet still he feels he has not exhausted all the possibilities for paintings. His quest is to wrest the essence of his deepest feeling for the country—and the essence of every moment spent with people who have touched his life. We witness these experiences in his landscapes and his portraits. The countryside he loves is the backdrop for his visions.

The country surrounding the village of Chadds Ford is a rich agricultural area first settled and tilled by a mixture of Swedes, Finns, Englishmen, Catholics and Quakers. The soil and the streams fed these first settlers to the region, and dense woods provided timber for the first log homes built in the territory of the New World.

Today, agriculture is slowly declining in the valley. The rural countryside is gradually transforming into a residential community as farms are being sold in large tracts for development. The path the artist walks from his studio to the Kuerner farm—the setting for more than four hundred studies and finished paintings over the past forty years—has been altered by the gradual change in the landscape. Posted warnings to trespassers require permission from new landowners to walk through familiar woods.

But this too is a part of the changing scene of the artist's world. A study of Andrew Wyeth's work, from his earliest watercolors to his present-day dry brush and tempera, reveals the artist's reaction to change. The true joy of following the art of Andrew Wyeth lies in the anticipation of what his reactions will be to the future.

Andrew Wyeth is an artist who is deeply rooted to the country he has always called home. His life and life's work in Chadds Ford, Pennsylvania, is a commitment through love for his work, for a small patch of countryside in the Brandywine Valley, and for a people who will gladly call him friend.

NATURE

O NATURE I DO NOT ASPIRE
TO BE THE HIGHEST IN THY QUIRE,
TO BE A METEOR IN THE SKY
OR COMET THAT MAY RANGE ON HIGH,
ONLY A ZEPHYR THAT MAY BLOW
AMONG THE REEDS BY THE RIVER LOW.
GIVE ME THY MOST PRIVY PLACE
WHERE TO RUN MY AIRY RACE.
IN SOME WITHDRAWN UNPUBLIC MEAD
LET ME SIGH UPON A REED,
OR IN THE WOODS WITH LEAFY DIN
WHISPER THE STILL EVENING IN,
FOR I HAD RATHER BE THY CHILD
AND PUPIL IN THE FOREST WILD
THAN BE THE KING OF MEN ELSEWHERE
AND MOST SOVEREIGN SLAVE OF CARE
TO HAVE ONE MOMENT OF THY DAWN
THAN SHARE THE CITY'S YEAR FORLORN.
SOME STILL WORK GIVE ME TO DO
ONLY BE IT NEAR TO YOU.

I WENT TO THE WOODS BECAUSE I WISHED TO LIVE DELIBERATELY,
TO FRONT ONLY THE ESSENTIAL FACTS OF LIFE, AND SEE IF
I COULD NOT LEARN WHAT IT HAD TO TEACH, AND NOT, WHEN
I CAME TO DIE, DISCOVER THAT I HAD NOT LIVED.

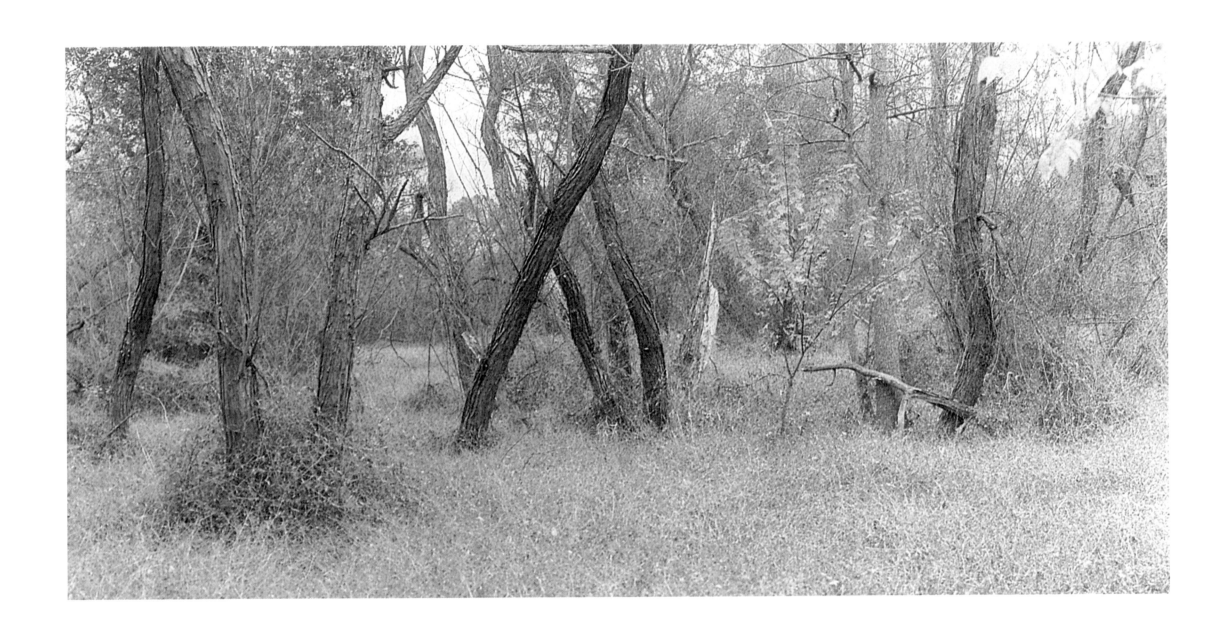

I DID NOT WISH TO LIVE WHAT WAS NOT LIFE, LIVING IS SO
DEAR; NOR DID I WISH TO PRACTICE RESIGNATION, UNLESS
IT WAS QUITE NECESSARY. I WANTED TO LIVE DEEP, AND SUCK
OUT ALL THE MARROW OF LIFE…TO DRIVE LIFE INTO A
CORNER, AND REDUCE IT TO ITS LOWEST TERMS, AND IF IT
PROVED TO BE MEAN, WHY THEN TO GET THE WHOLE AND GENUINE
MEANNESS OF IT…OR IF IT WERE SUBLIME, TO KNOW IT
BY EXPERIENCE…

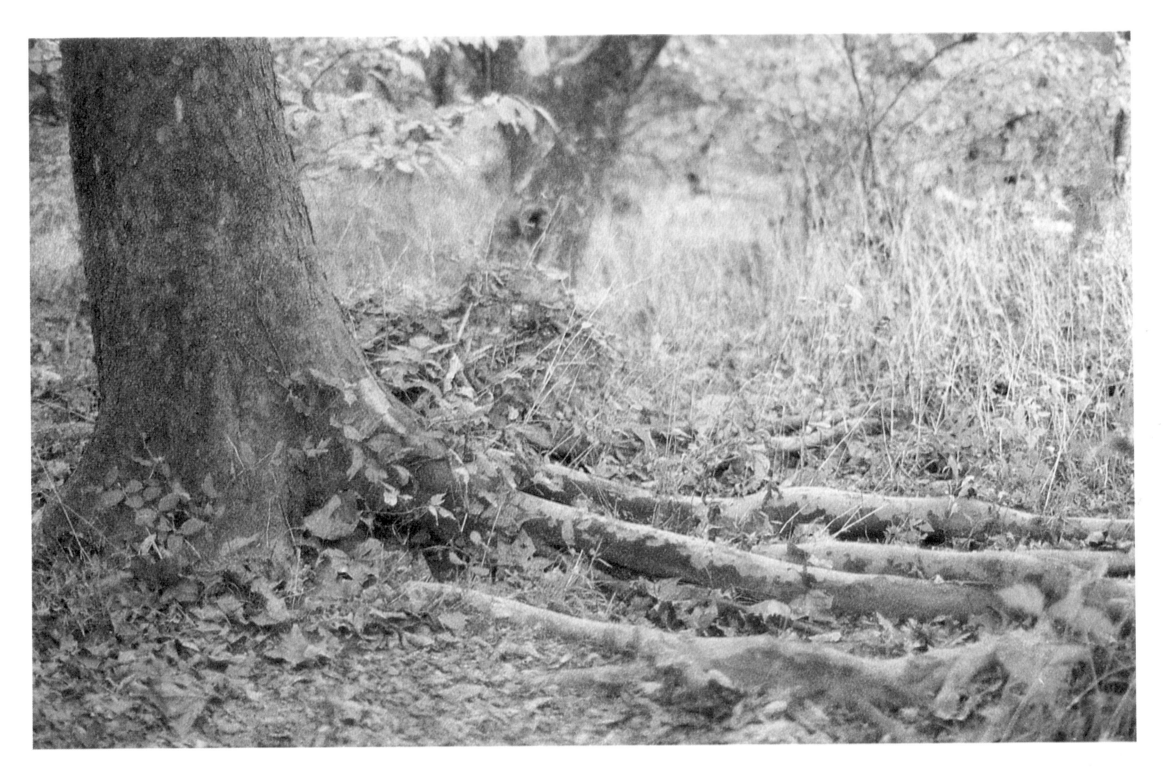

IN WINTER, I STOP SHORT IN THE PATH TO ADMIRE HOW THE
TREES GROW UP WITHOUT FORETHOUGHT, REGARDLESS OF THE
TIME AND CIRCUMSTANCES. THEY DO NOT WAIT AS MAN DOES,
BUT NOW IS THE GOLDEN AGE OF THE SAPLING. EARTH, AIR,
SUN, AND RAIN ARE OCCASION ENOUGH; THE "WINTER OF *THEIR*
DISCONTENT" NEVER COMES.

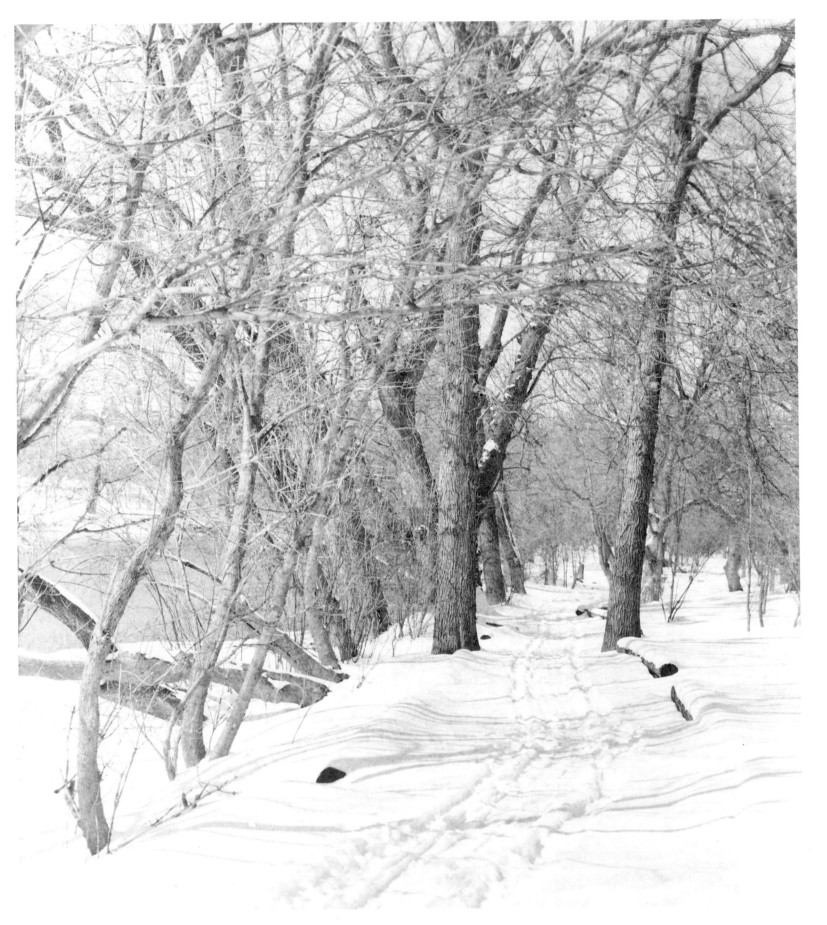

ART IS NOT TAME, AND NATURE IS NOT WILD, IN THE ORDINARY SENSE. A PERFECT WORK OF MAN'S ART WOULD ALSO BE WILD OR NATURAL IN A GOOD SENSE. MAN TAMES NATURE ONLY THAT HE MAY AT LAST MAKE HER MORE FREE EVEN THAN HE FOUND HER...

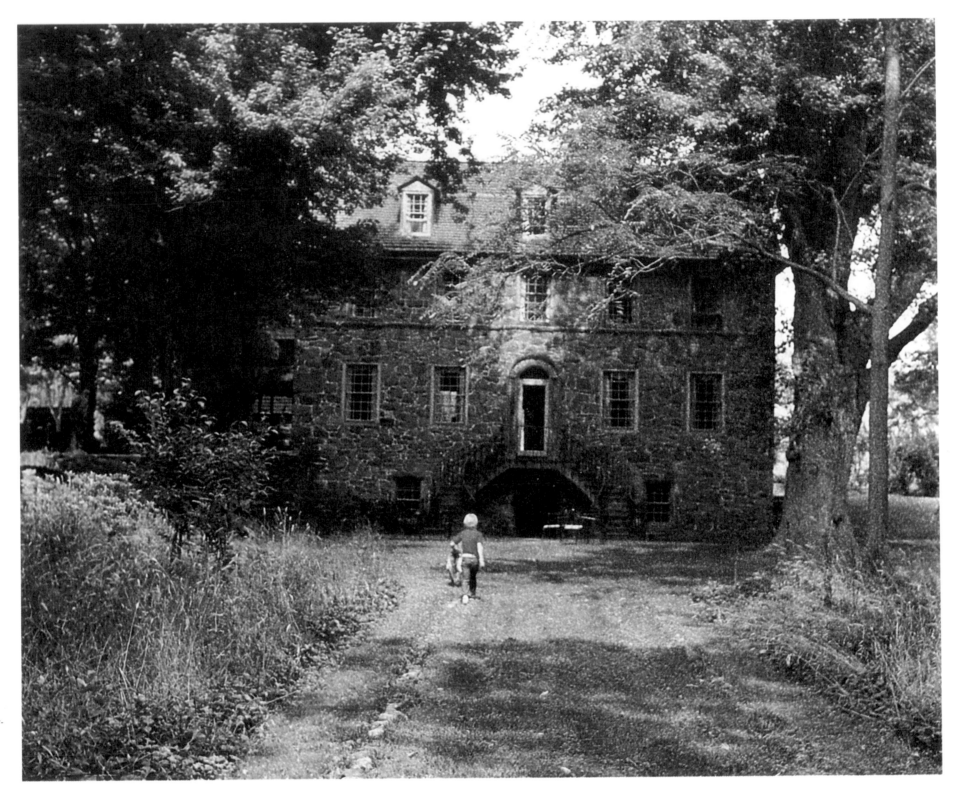

The House at Big Bend. A country home outside the village at a point on the river that is known as Big Bend. The countryside is rich in history of its first Indian inhabitants. One of the rooms in the manor house once served as an Indian trading post.

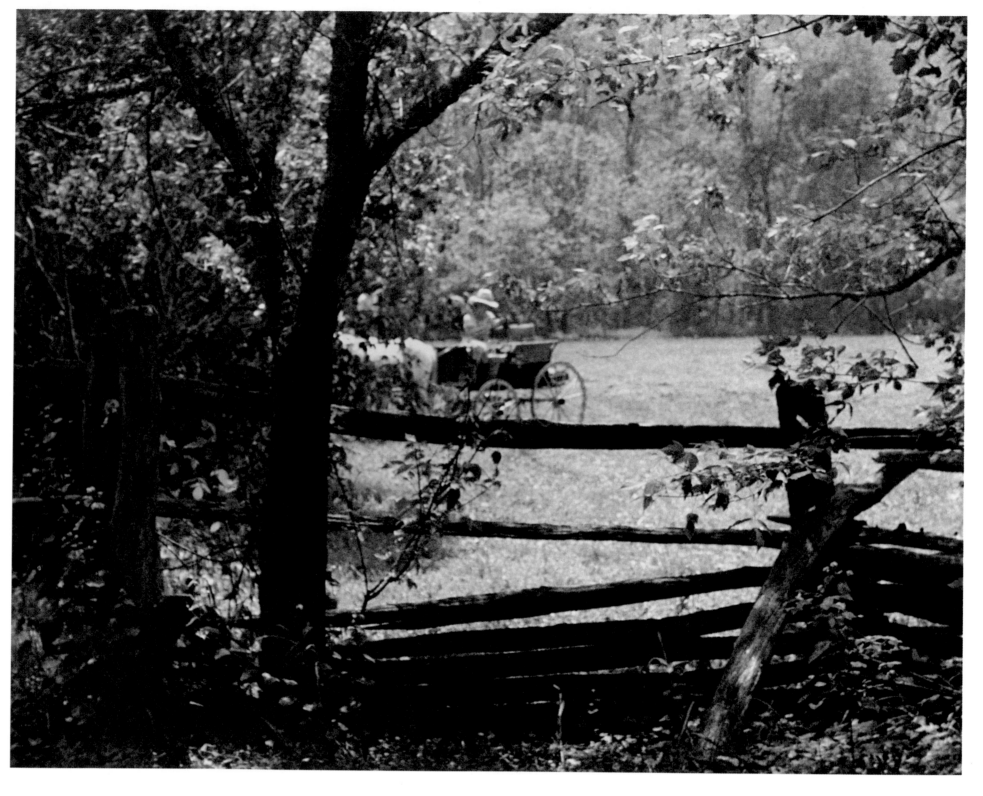

Carriage Show. An annual, festive weekend event at the house at Big Bend. The owners host guests from all over the country and from England who come for the sporting occasion.

THE WORKS OF MAN ARE EVERYWHERE SWALLOWED UP IN THE IMMENSITY OF NATURE.

Carriage dog.

THE WILDEST SCENES HAVE AN AIR OF DOMESTICITY...
IN THE WILDEST NATURE, THERE IS NOT ONLY THE MATERIAL
OF THE MOST CULTIVATED LIFE...BUT A GREATER REFINEMENT
ALREADY THAN IS EVER ATTAINED BY MAN.

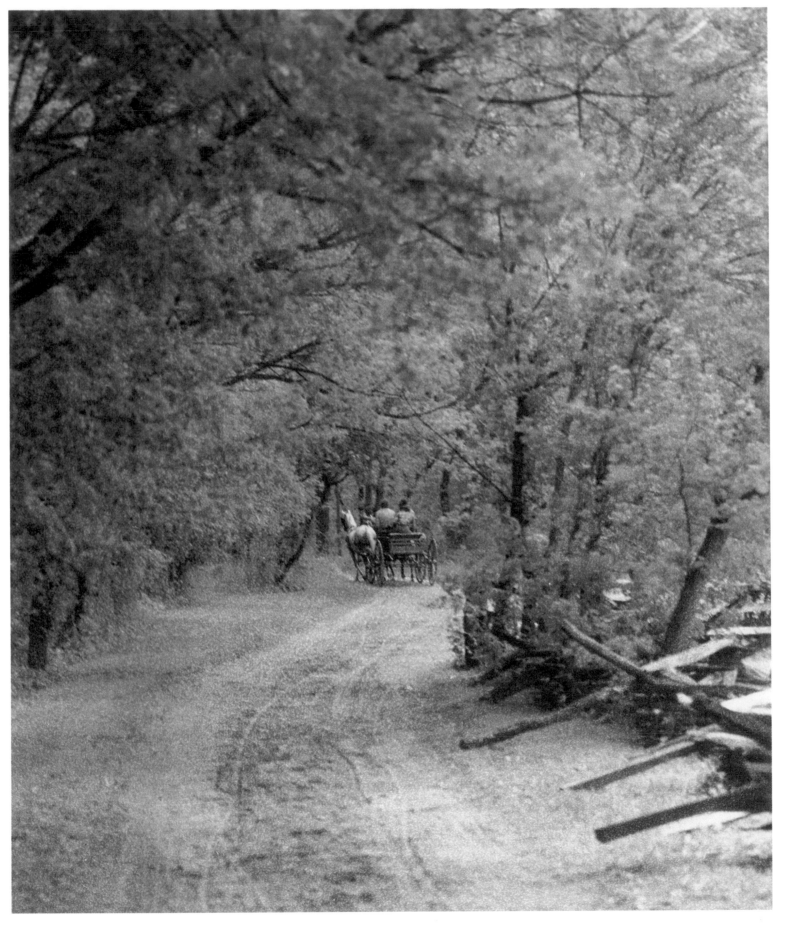

THESE FARMS WHICH I HAVE MYSELF SURVEYED, THESE
BOUNDS WHICH I HAVE SET UP, APPEAR DIMLY STILL AS
THROUGH A MIST; BUT THEY HAVE NO CHEMISTRY TO FIX
THEM; THEY FADE FROM THE SURFACE OF THE GLASS, AND THE
PICTURE WHICH THE PAINTER PAINTED STANDS OUT DIMLY FROM
BENEATH.

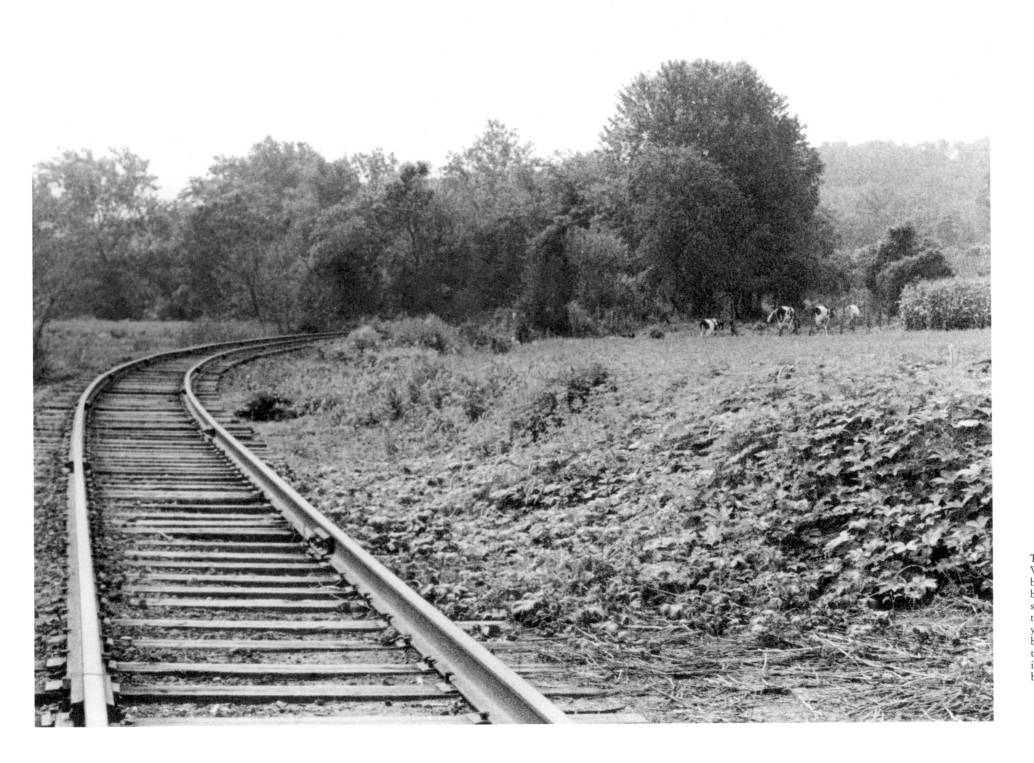

The Woodward Farm. The Woodward farm sits high on the banks of the Brandywine. It is a boat ride up the river to this scene. The artist has made the trip countless times over the years. It was the drying yard behind the farm house that was the scene for the tempera painting "Slight Breeze," completed by the artist in 1968.

I FOUND IN MYSELF, AND STILL FIND, AN INSTINCT TOWARD
A HIGHER, OR, AS IT IS NAMED, SPIRITUAL LIFE, AS DO
MOST MEN, AND ANOTHER TOWARD A PRIMITIVE RANK, AND
SAVAGE ONE, AND I REVERENCE THEM BOTH.

I LOVE THE WILD NOT LESS THAN THE GOOD. I LIKE SOMETIMES
TO TAKE RANK HOLD ON LIFE AND SPEND MY DAYS MORE AS THE
ANIMALS DO.

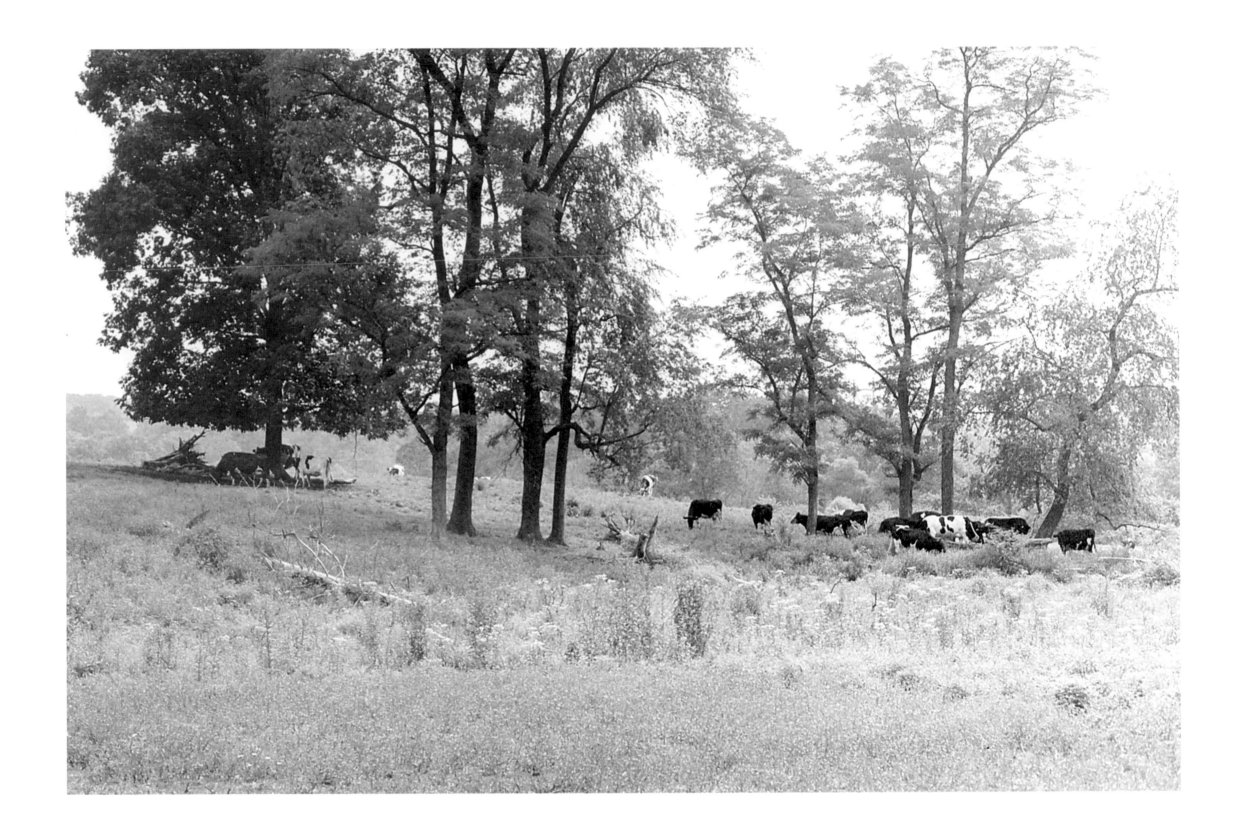

DIRECT YOUR EYE RIGHT INWARD, AND YOU'LL FIND
A THOUSAND REGIONS IN YOUR MIND YET UNDISCOVERED.
TRAVEL THEM AND BE EXPERT IN HOME-COSMOGRAPHY.

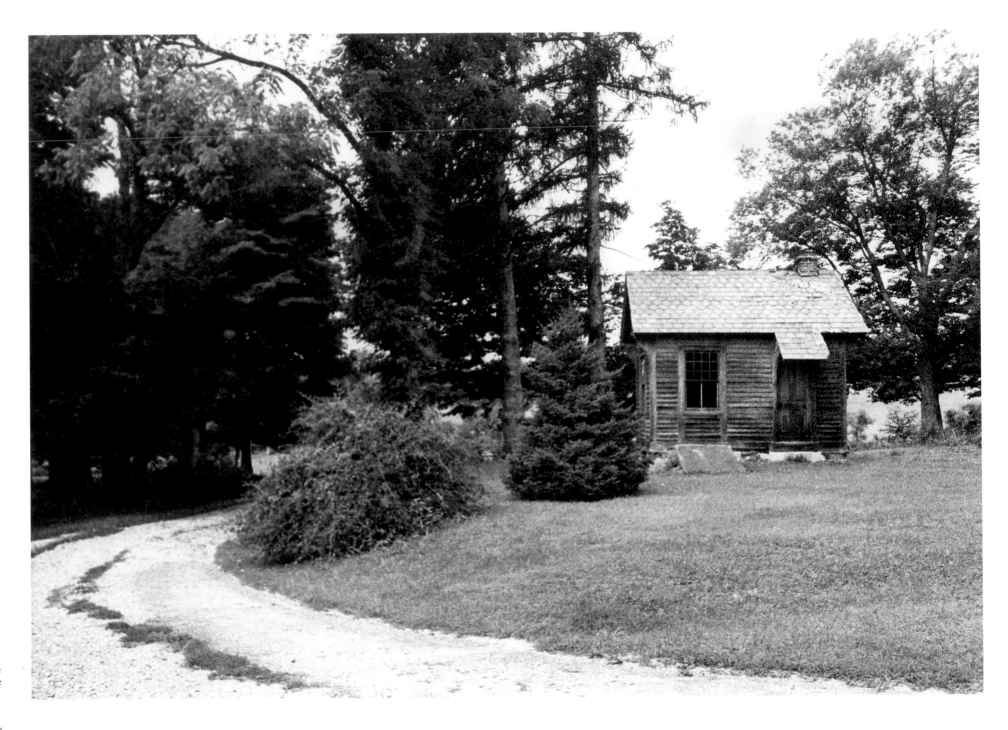

The Wylie farm is a drive up the river valley from the village. The artist's father used to place his order for winter firewood with the Wylies. The artist does the same today. It was a scene inside one of the cooling sheds on the Wylie farm that became the subject for a 1953 tempera painting by the artist titled "Cooling Shed."

DO NOT SEEK SO ANXIOUSLY TO BE DEVELOPED, TO SUBJECT
YOURSELF TO MANY INFLUENCES TO BE PLAYED ON; HUMILITY
LIKE DARKNESS REVEALS THE HEAVENLY LIGHTS.

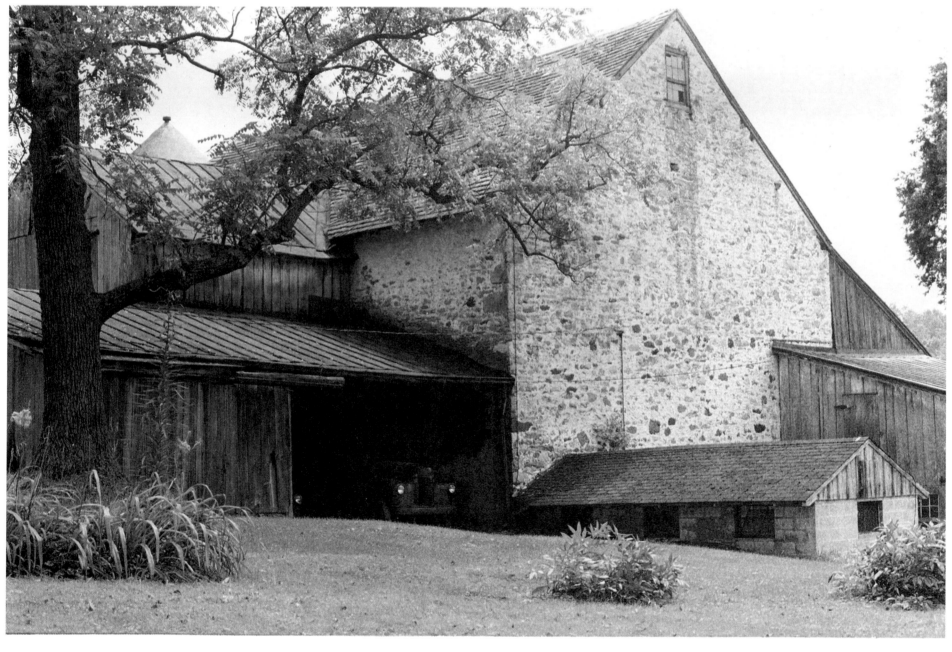

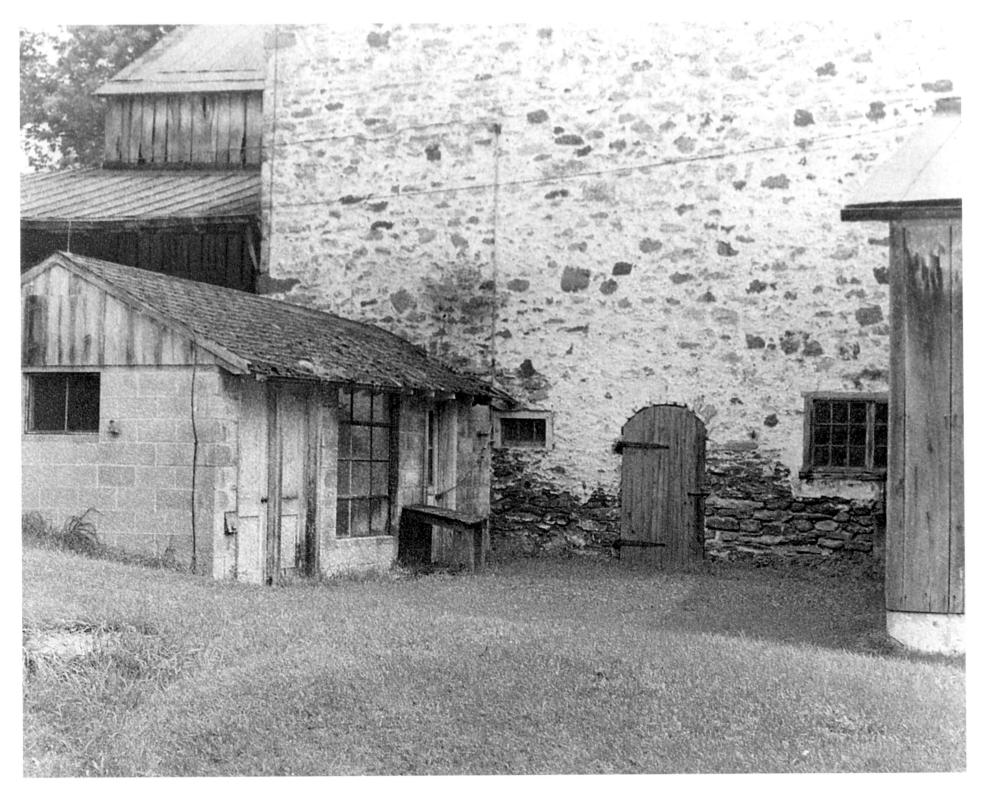

Barn and buildings on the Wylie
farm.

HE IS THE RICH MAN AND ENJOYS THE FRUITS OF RICHES,
WHO SUMMER AND WINTER FOREVER CAN FIND DELIGHT IN HIS
OWN THOUGHTS...WHEN I VISIT AGAIN SOME HAUNT OF MY
YOUTH, I AM GLAD TO FIND THAT NATURE WEARS SO WELL.
THE LANDSCAPE IS INDEED SOMETHING REAL, AND SOLID, AND
SINCERE, AND I HAVE NOT PUT MY FOOT THROUGH IT YET.

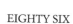

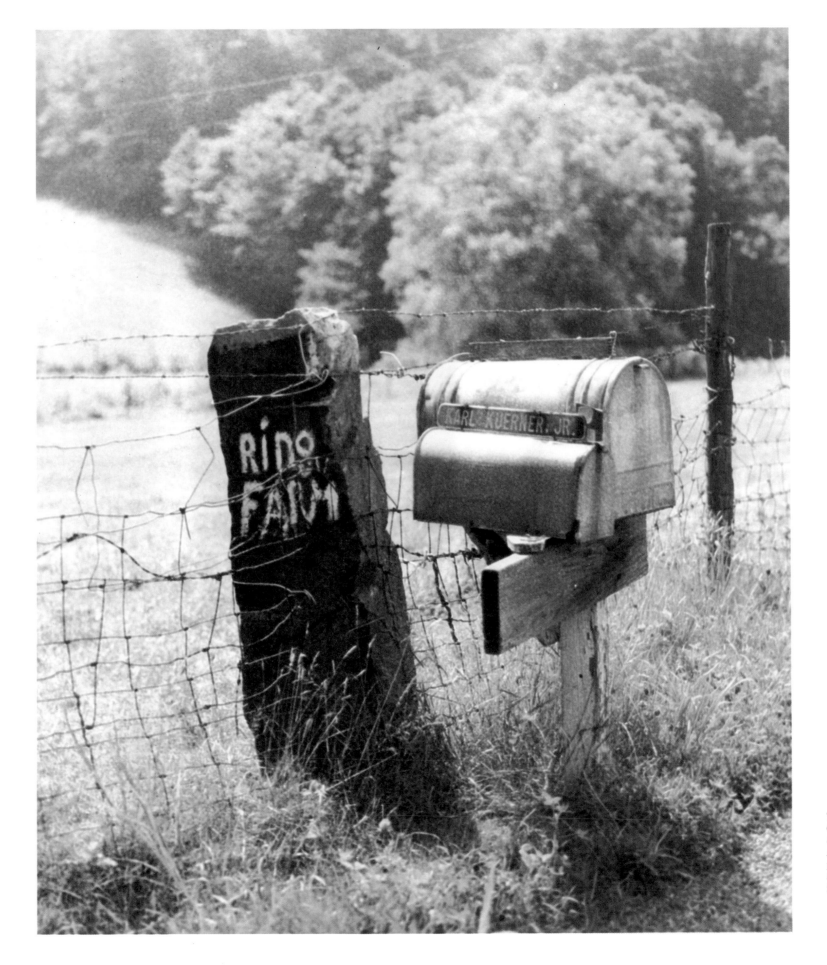

The Kuerner Farm. The farm in Chadds Ford that has been central to the life and work of Andrew Wyeth. The artist has painted from scenes in and around the Kuerner house and farm for more than forty years.

IN THE HUES OF OCTOBER...WE SEE THE PORTALS TO OTHER
MANSIONS THAN THOSE WHICH WE OCCUPY, NOT FAR OFF GEOGRAPHICALLY.

Since boyhood, the artist has walked a path to Kuerner's farm; through woods past his father's house, across fields and then a pasture where Kuerner's Brown Swiss cattle graze on the slope of a hill. The area has grown over the years with the expansion of residential development. The scenery has changed, Karl Kuerner has passed away, some of the farmland has been sold. But the artist still travels the path to the place that holds vivid memories and deep affection for him.

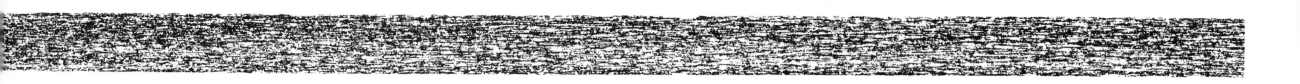

MY VICINITY AFFORDS MANY GOOD WALKS; AND THOUGH FOR
SO MANY YEARS I HAVE WALKED ALMOST EVERY DAY, AND
SOMETIMES FOR SEVERAL DAYS TOGETHER, I HAVE NOT YET
EXHAUSTED THEM. AN ABSOLUTELY NEW PROSPECT IS A GREAT
HAPPINESS, AND I CAN STILL GET THIS ANY AFTERNOON.
TWO OR THREE HOURS WALKING WILL CARRY ME TO AS STRANGE
A COUNTRY AS I EXPECT EVER TO SEE...IT WILL NEVER
BECOME QUITE FAMILIAR TO YOU.

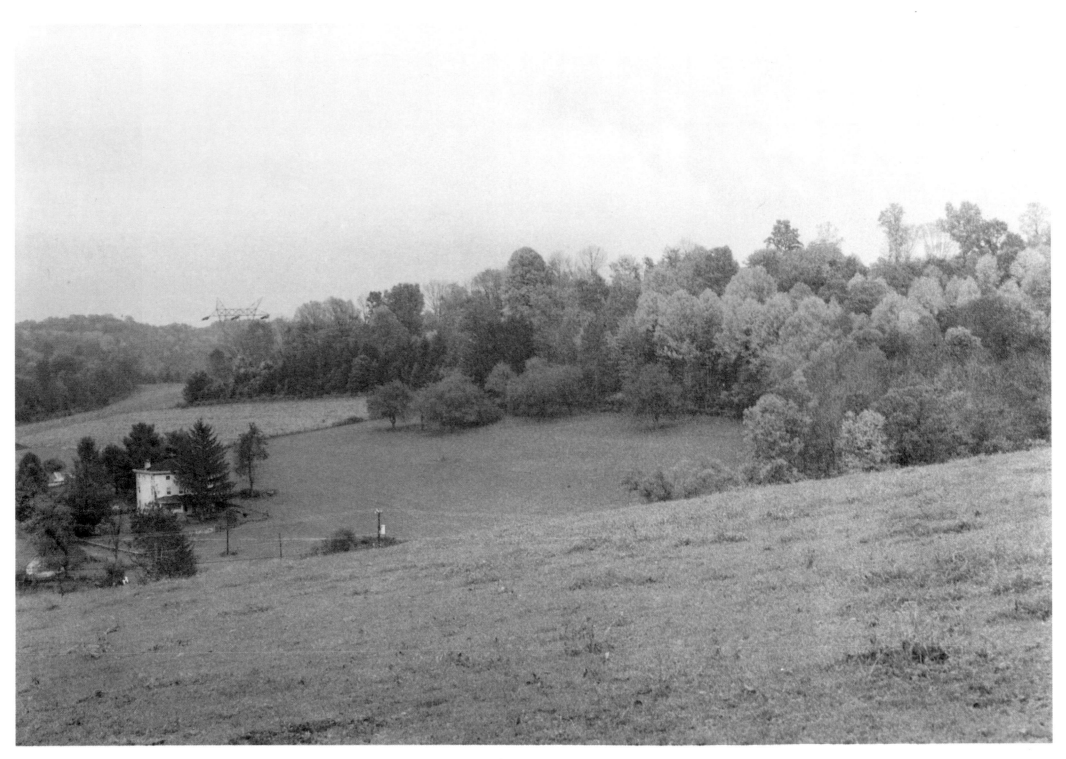

IF I WERE AWAKENED FROM A DEEP SLEEP, I SHOULD KNOW WHICH SIDE OF THE MERIDIAN THE SUN MIGHT BE BY THE ASPECT OF NATURE, AND YET NO PAINTER CAN PAINT THE DIFFERENCE.

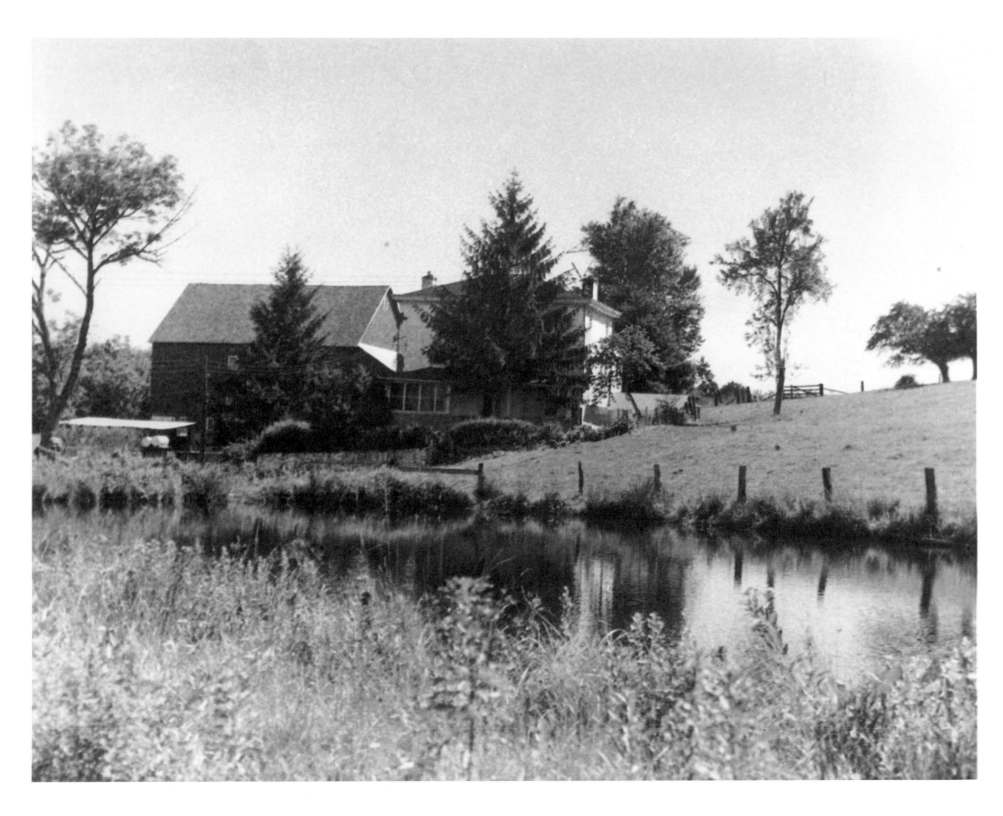

The farm pond on Kuerner's reflects a corner of the Pennsylvania farmhouse where the artist has been in and out of rooms over the years, painting from life –and now from memory– portraits of its owner. Karl Kuerner's love was hunting. During his lifetime he was considered an expert shot, and he was a much respected farmer. Wyeth's 1954 Watercolor, "Karl's Room," was a scene from a corner of Karl's bedroom.

WHEN I DETECT A BEAUTY IN ANY OF THE RECESSES OF NATURE,
I AM REMINDED, BY THE SERENE AND RETIRED SPIRIT IN WHICH
IT REQUIRES TO BE CONTEMPLATED, OF THE INEXPRESSIBLE
PRIVACY OF A LIFE–HOW SILENT AND UNAMBITIOUS IT IS.

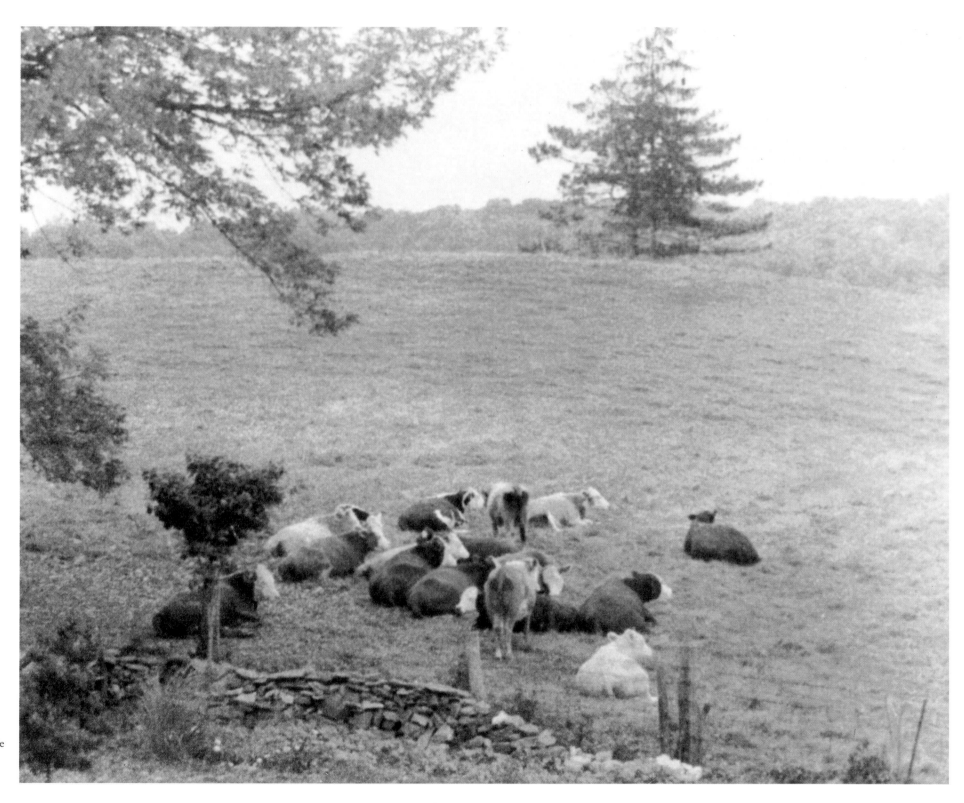

The cows at Kuerner's farm, reclining on the side of Kuerner's hill.

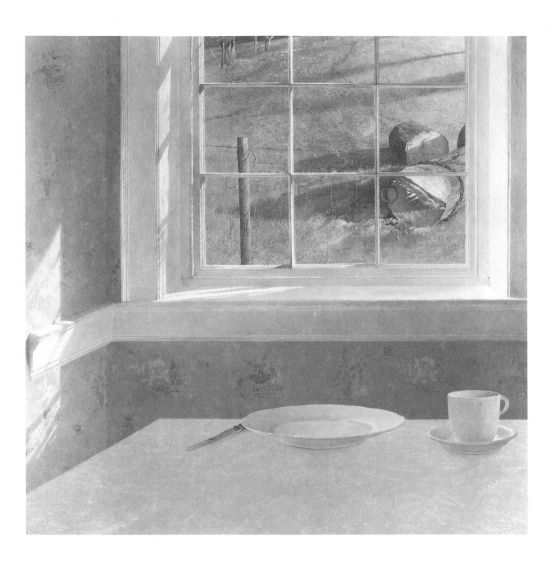

"Ground Hog Day." Tempera,
1959 by Andrew Wyeth.

Courtesy of The Philadelphia
Museum of Art.

Given by Henry F. Dupont and
Mrs. John Wintersteen.

(alternate)

Given by Henry F. DuPont and
Mrs. John Wintersteen.

THE WONDERFUL PURITY OF NATURE AT THIS SEASON IS A
MOST PLEASING FACT. EVERY DECAYED STUMP AND MOSS-GROWN
STONE AND RAIL, AND THE DEAD LEAVES OF AUTUMN, ARE
CONCEALED BY A CLEAN NAPKIN OF SNOW. IN THE BARE
FIELDS AND TINKLING WOODS, SEE WHAT VIRTUE SURVIVES.
ALL THINGS BESIDE SEEM TO BE CALLED IN FOR SHELTER,
AND WHAT STAYS OUT MUST BE PART OF THE ORIGINAL FRAME
OF THE UNIVERSE...

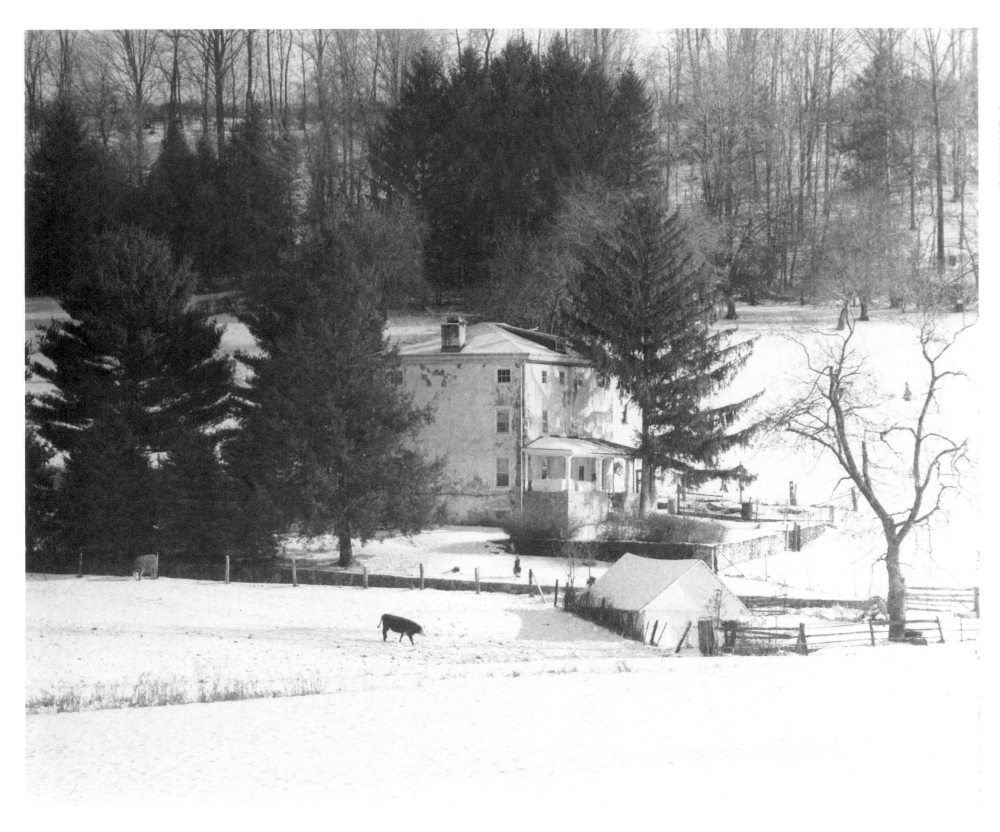

Winter at Kuerner's. The 1959 tempera painting "Ground Hog Day" illustrates a scene inside the kitchen at Keurner's farm. It is the winter months and white, fallen snow that the artist loves to paint.

I LOVE TO WEIGH, TO SETTLE, TO GRAVITATE TOWARD THAT
WHICH MOST STRONGLY AND RIGHTFULLY ATTRACTS ME...TO
TRAVEL THE ONLY PATH I CAN, AND THAT ON WHICH NO POWER
CAN RESIST ME.

"First Snow." Dry brush, 1959 by Andrew Wyeth.

Courtesy of Delaware Art Museum, Wilmington, Delaware.

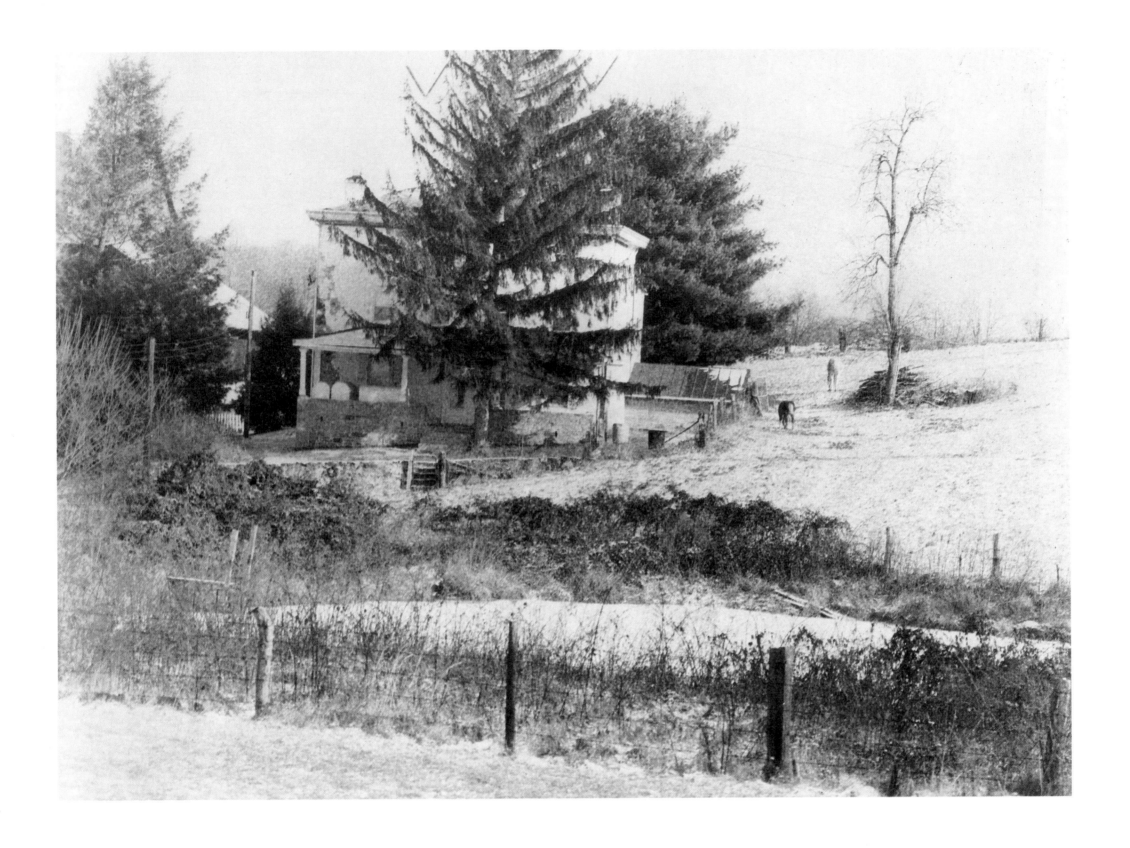

NOW OUR PATH BEGINS TO ASCEND GRADUALLY TO THE TOP
OF THIS HIGH HILL, FROM WHOSE PRECIPITOUS SIDE WE
CAN LOOK OVER THE BROAD COUNTRY OF FOREST AND FIELD...
IT IS A HIEROGLYPHIC OF MAN'S LIFE...AND SUCH IS
THE BEGINNING OF...THE ESTABLISHMENT OF THE ARTS,
AND THE FOUNDATIONS OF EMPIRES.

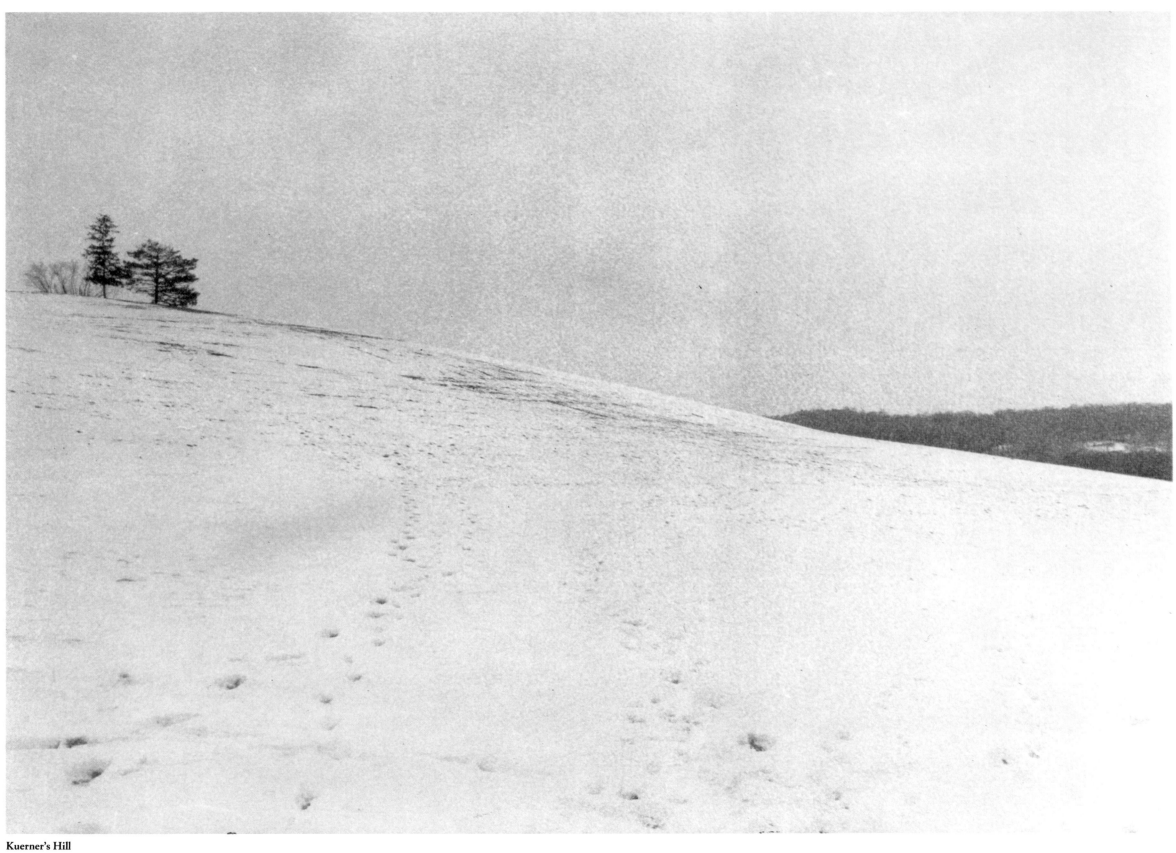

Kuerner's Hill

…IF YOU ARE RESTRICTED IN YOUR RANGE BY POVERTY…
YOU ARE BUT CONFINED TO THE MOST SIGNIFICANT AND VITAL
EXPERIENCES; YOU ARE COMPELLED TO DEAL WITH THE MATERIAL
WHICH YIELDS THE MOST SUGAR AND THE MOST STARCH. IT
IS LIFE NEAR THE BONE WHERE IT IS SWEETEST.

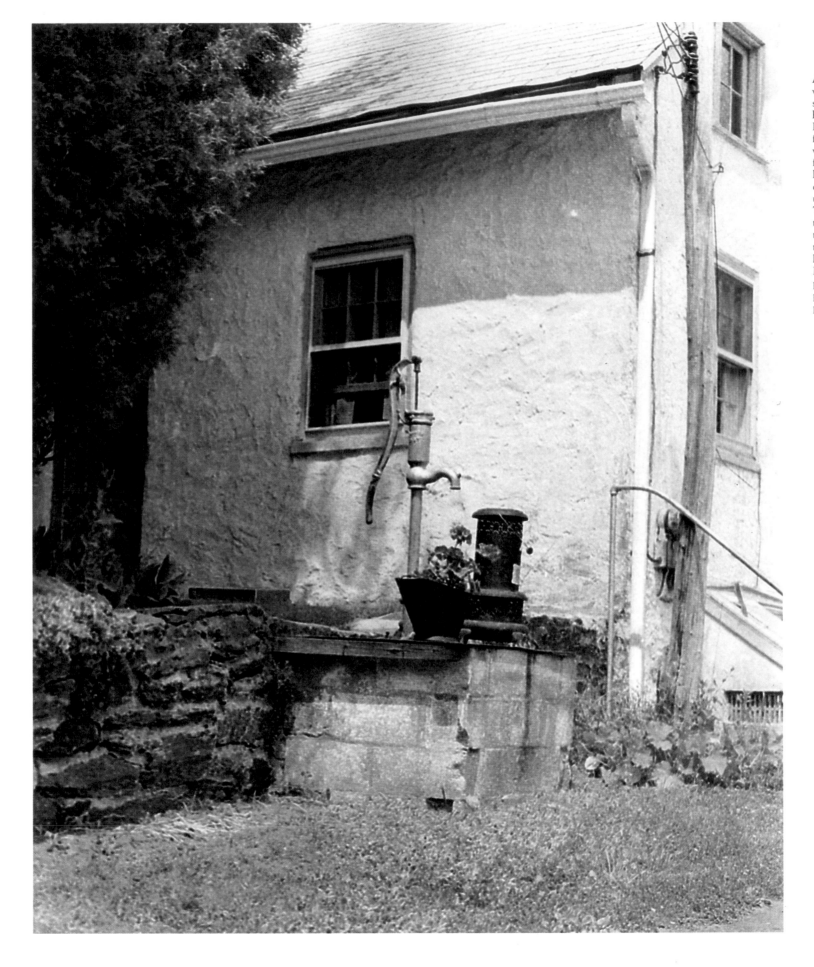

Adam Johnson's. Adam Johnson was a friend of the artist. His small farm was on the side of a hill, down the road from Kuerner's. He had a reputation for keeping a very neat house, while the outbuildings on his farm were made from salvaged lumber and scraps of material collected in his job of cleaning up other people's property. Today, Adam Johnson is gone; the dirt road that used to run by the side of his house is now a two-lane, paved road. Wyeth has kept the memory of his old Negro friend alive in numerous portraits. The most well known portrait is "Adam," a tempera painting completed in 1963.

I ONLY KNOW MYSELF AS A HUMAN ENTITY: THE SCENE, SO TO
SPEAK, OF THOUGHTS AND AFFECTIONS; AND AM SENSIBLE
OF A CERTAIN DOUBLENESS BY WHICH I CAN STAND AS REMOTE
FROM MYSELF AS FROM ANOTHER. HOWEVER INTENSE MY EXPERIENCE,
I AM CONSCIOUS OF THE PRESENCE AND CRITICISM OF A PART
OF ME, WHICH, AS IT WERE, IS NOT A PART OF ME, BUT A
SPECTATOR.

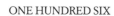

A view of Adam Johnson's house viewed through the ruins at Mother Archie's. Down the road from Adam Johnson's is a spot once known as Archie's Corner, the location of an abandoned Quaker schoolhouse turned into a church by the town's Negroes. The church was known as Mother Archie's, named for the community's beloved preacher.

The scene which the artist painted in "The Corner," a 1953 dry brush painting, had disappeared by 1954. Today, all that remains are ruins.

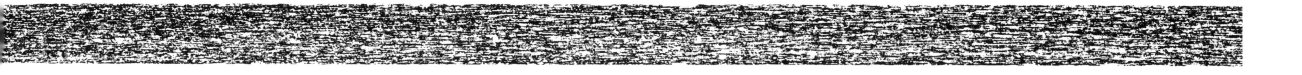

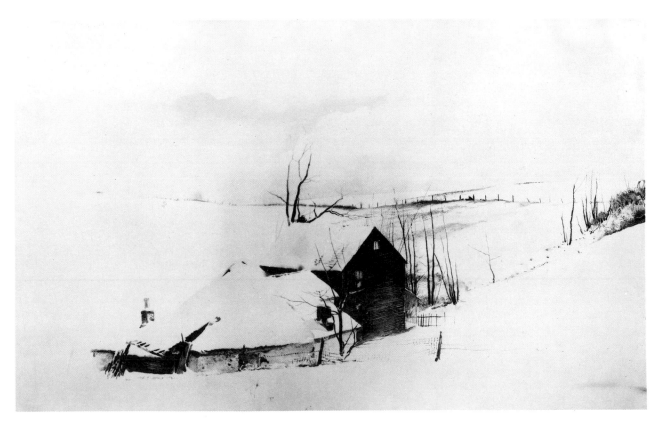

"The Corner." Dry brush, 1953 by Andrew Wyeth.

Courtesy of The Delaware Art Museum, Wilmington, Delaware.

Ruins at Mother Archie's Corner. Kuerner's Hill is in the distance.

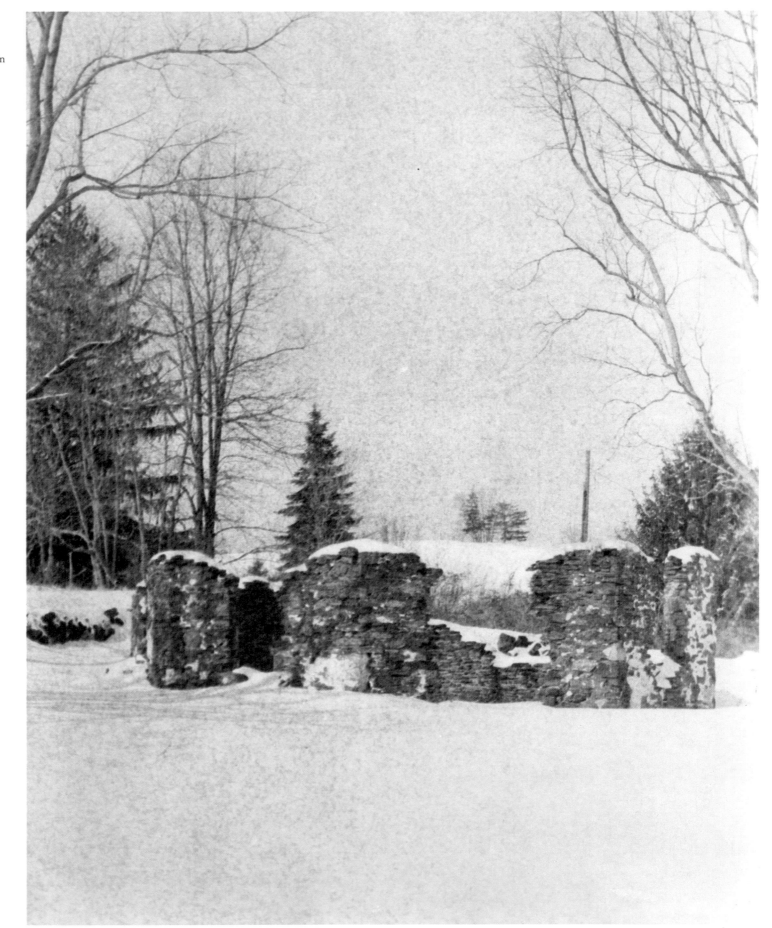

SILENCE IS AUDIBLE TO ALL MEN, AT ALL TIMES, AND IN
ALL PLACES. SHE IS WHEN WE HEAR INWARDLY, SOUND WHEN
WE HEAR OUTWARDLY. CREATION HAS NOT DISPLACED HER, BUT
IS HER VISIBLE FRAMEWORK AND FOIL.

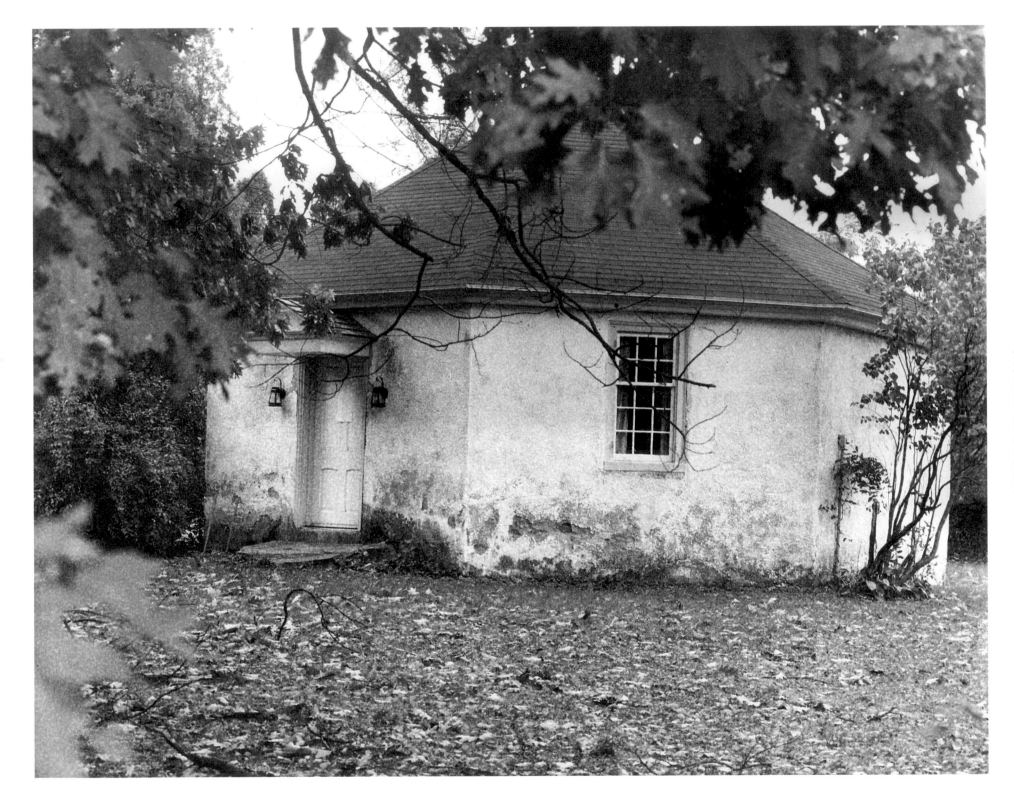

The Birmingham Quaker Meeting House. The country above the Ford known as Birmingham was a scene of confrontation between the colonists and British troops during the Battle of Brandywine. But amid the road signs in the area that mark these historic confrontations stand such peaceful reminders of the Quaker influence in the valley's early history.

STANDING QUITE ALONE AND LEAVING THE ONLY HUMAN TRACKS
BEHIND US, WE FIND OUR REFLECTIONS OF A RICHER VARIETY
THAN THE LIFE OF THE CITIES. IN THIS LONELY GLEN, OUR
LIVES ARE MORE SERENE AND WORTHY TO CONTEMPLATE.

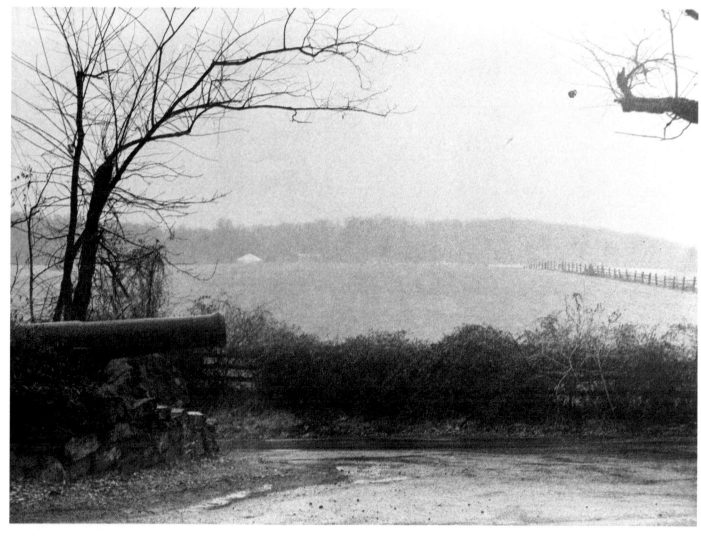

The country is deeply rooted to
its history in the American
Revolution. Along the road to
Birmingham, an iron cannon
rests on stone against a present-
day landscape.

Sentinels of pine stand watch
along a moss-green wall that
surrounds a Quaker cemetery in
the Birmingham countryside.

WHEN A TRAVELER ASKED WORDSWORTH'S SERVANT TO SHOW HIM HER MASTER'S STUDY, SHE ANSWERED, "HERE IS HIS LIBRARY, BUT HIS STUDY IS OUT OF DOORS."

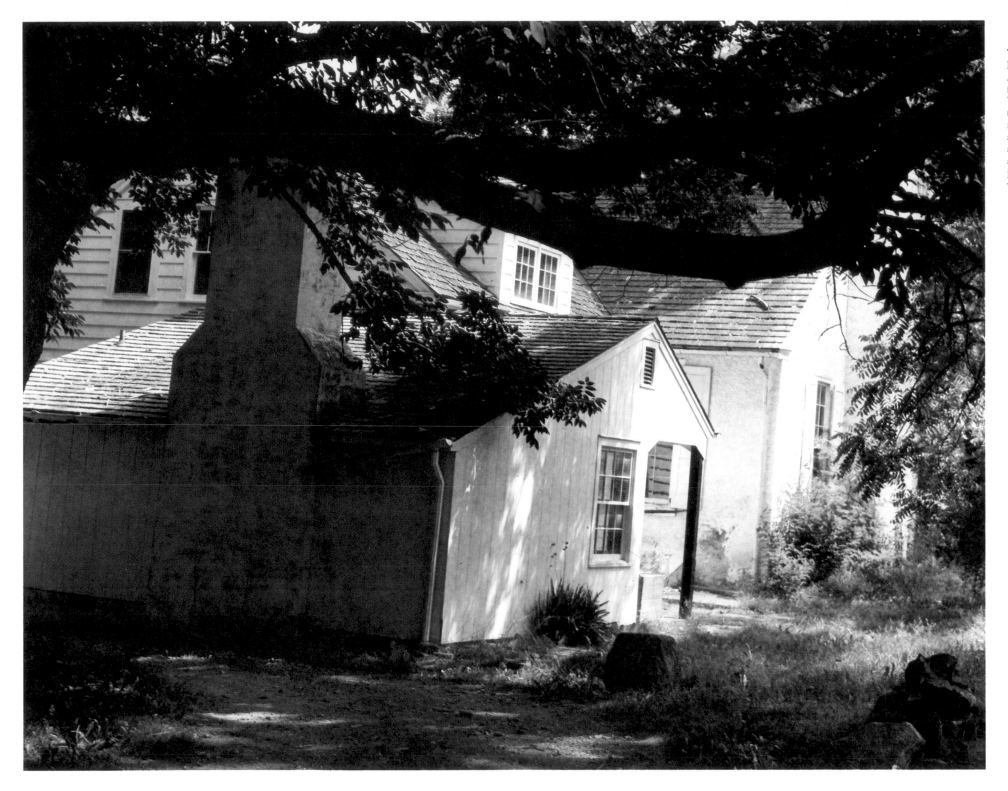

The artist's studio in Chadds Ford. The greater portion of Andrew Wyeth's work is done from studies made out of doors. Whatever aspects of life outside the studio walls appeal to his imagination, whatever memories are stirred by the countryside and the people for whom he has a deep love, these are the subjects which he paints. The final work is done in his studio.

ONE HUNDRED FIFTEEN

I LEFT THE WOODS FOR AS GOOD A REASON AS I WENT THERE. PERHAPS IT SEEMED TO ME THAT I HAD SEVERAL MORE LIVES TO LIVE, AND COULD NOT SPARE ANY MORE TIME FOR THAT ONE.

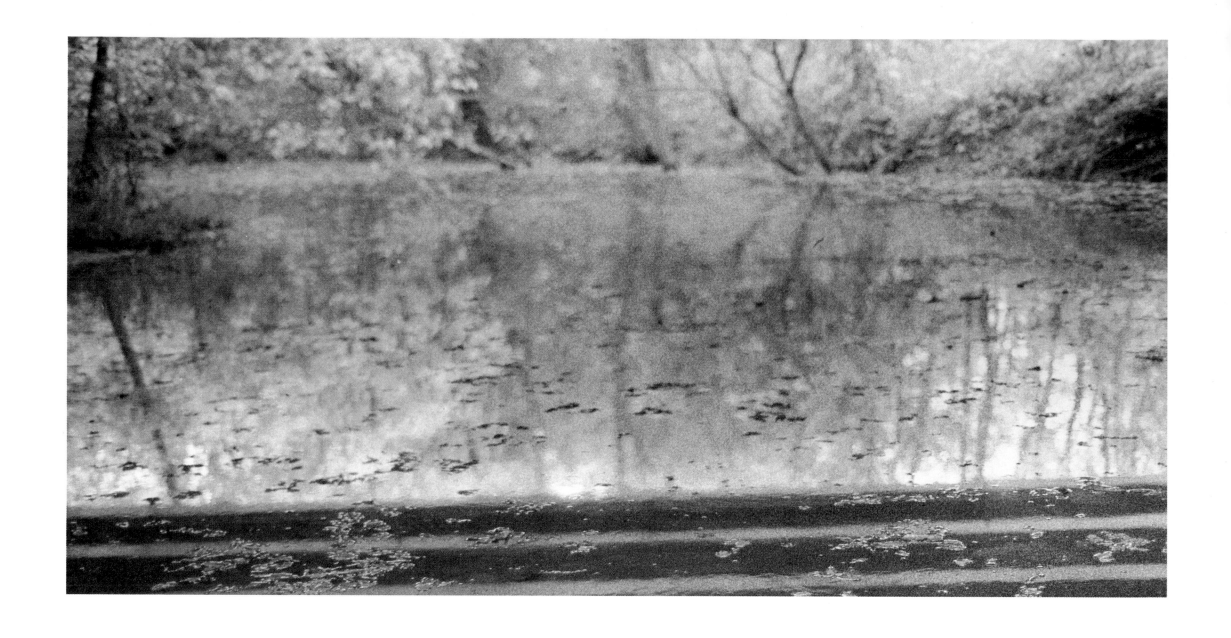

I WOULD NOT HAVE ANYONE ADOPT MY MODE OF LIVING…
BUT I WOULD HAVE EACH ONE BE VERY CAREFUL TO FIND OUT
AND PURSUE HIS OWN WAY, AND NOT HIS FATHER'S OR HIS
MOTHER'S…WE MAY NOT ARRIVE AT OUR PORT WITHIN A
CALCULABLE PERIOD, BUT WE WOULD PRESERVE THE TRUE COURSE.

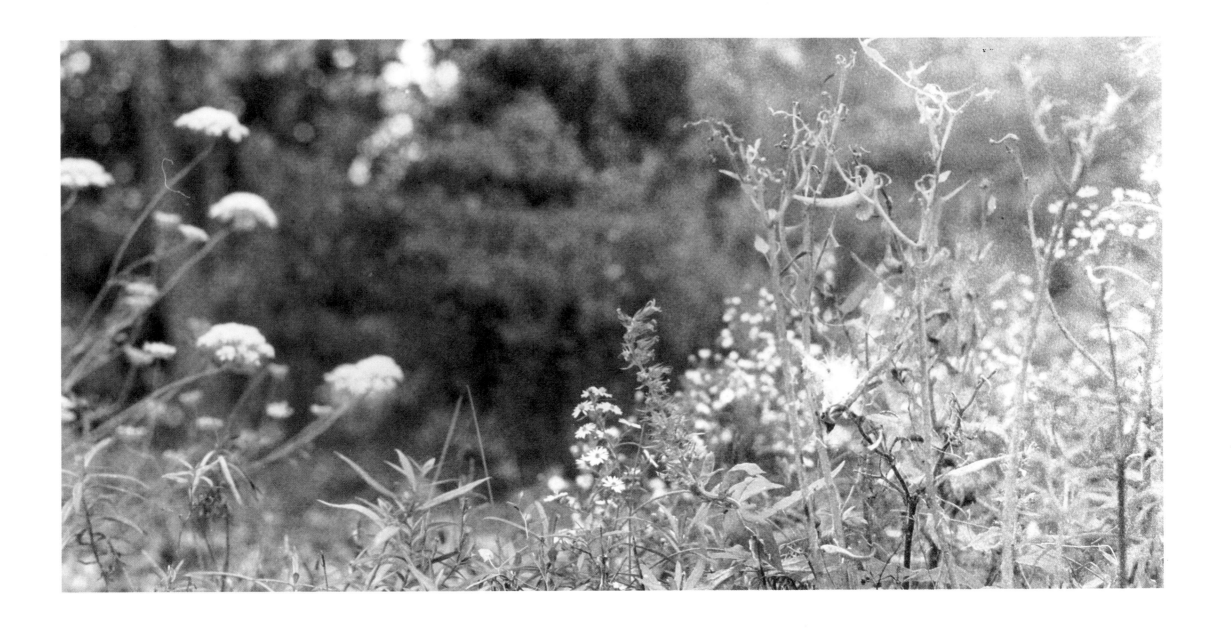

THE MATERIAL WAS PURE, AND HIS ART WAS PURE; HOW COULD
THE RESULT BE OTHER THAN WONDERFUL?

An extensive collection of the art of Andrew Wyeth can be
seen at The Brandywine River Museum in Chadds Ford, Pennsylvania.

The photographers wish to express their sincere gratitude
to those people along the way who graciously took an interest in this project.

Cover design by Joseph Curcio
Interior design by Madeline & Harvey Hersh

BOOKS WITH PHOTOGRAPHS BY JAMES A. WARNER

THE GENTLE PEOPLE, A Portrait of the Amish
Warner/Denlinger

THE QUIET LAND

SONGS THAT MADE AMERICA

THE DARKER BROTHER
Warner/Slade

THE MORMON WAY
Warner/Slade

BEST FRIENDS
Warner/White

THE JOURNEY
Warner/White

CHESAPEAKE, A PORTRAIT OF THE BAY COUNTRY
Warner/White

THE DECOY AS ART: WATERFOWL IN A WOODEN SOUL
Warner/White

IN THE FOOTSTEPS OF THE ARTIST: THOREAU AND THE WORLD OF ANDREW WYETH
Warner/White

BOOKS WITH PHOTOGRAPHS AND TEXT BY MARGARET J. WHITE

BEST FRIENDS
Warner/White

THE JOURNEY
Warner/White

CHESAPEAKE, A PORTRAIT OF THE BAY COUNTRY
Warner/White

THE DECOY AS ART: WATERFOWL IN A WOODEN SOUL
Warner/White

IN THE FOOTSTEPS OF THE ARTIST: THOREAU AND THE WORLD OF ANDREW WYETH
Warner/White